IMAGES
of Modern America

COATESVILLE

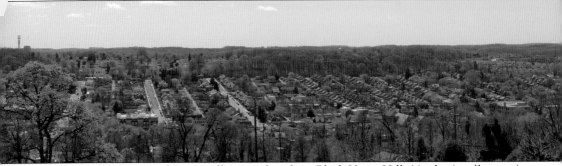

This panoramic view of Coatesville was taken from Black Horse Hill. (Author's collection.)

IMAGES

of Modern America

COATESVILLE

To Frank and Theresa

Karol Collins

Karol Collins

ARCADIA
PUBLISHING

Published by Arcadia Publishing
Charleston, South Carolina

Printed in the United States of America

Library of Congress Control Number: 2015943327

For all general information, please contact Arcadia Publishing:
Telephone 843-853-2070
Fax 843-853-0044
E-mail sales@arcadiapublishing.com
For customer service and orders:
Toll-Free 1-888-313-2665

Visit us on the Internet at www.arcadiapublishing.com

This book is dedicated to Coatesville and those that love, believe in, and call this little part of the world their home.

CONTENTS

ACKNOWLEDGMENTS

Many thanks go to those who willingly contributed during the process of bringing this project to life. You helped make this book possible with your time, knowledge, photographs, support, and friendship.

Big thank-yous go to my father, Robert Collins, cousin Patricia Ficca-Fisher, and cousin Raymond Ficca for putting names with faces in many photographs and my sister Kathy Collins-Hanthorne for riding around with me while I shot images to use for this project. And to Greg Vietri, my partner in life, thank you for everything.

Gratitude is extended to Dennis O'Neil, who provided many photographs from the Loggia Goffredo Mameli (L.G.M.), which was like opening up a time capsule that is missed by many and fondly remembered by all.

Greg DePedro and his father, Carmen, from the Coatesville Flower Shop allowed me to come into their shop and borrow great photographs from their walls to share with the world. Thank you both for your support and enthusiasm.

Thanks go to the National Iron and Steel Heritage Museum (NISHM) for the opportunity to have a front-row seat to Coatesville's past, present, and future. Scott Huston, Jim Ziegler, Sam Radziviliuk, Gene DiOrio, Sharon Tandarich, and the entire staff at NISHM and the Williams Group should be recognized for everything they do to preserve Coatesville's rich history.

To Jay Byerly and David DeSimone, thank you for the use of your private collections and for sharing your love of Coatesville with me.

For advice from the beginning, when this was just an idea, to assisting with the cover text, much love and gratitude go to my dearest friend, Jaca White-Spangler.

And many thanks go to the Brandywine Health Foundation and the Coatesville Christmas Parade, Inc., for giving me the opportunity to contribute to your organizations and in turn, giving me many great photo opportunities along the way. Thank you, with all of my heart for having faith, like I do, in the Coatesville community.

INTRODUCTION

Welcome to Coatesville, Pennsylvania, nestled between urban Philadelphia and rural Lancaster County. By virtue of Coatesville's location along the Brandywine River, it quickly grew into a prosperous community. In 1787, farmer (and first postmaster in the area) Moses Coates purchased land that is now the center of town.

In 1794, America's first turnpike was completed. The Philadelphia and Lancaster Turnpike (now known as US Route 30) brought unlimited opportunity to the area. In 1810, ironmaster Issac Pennock and Jesse Kersey (Moses Coates' son-in-law) formed a partnership and purchased 110 acres of Coates's farm along the Brandywine River, converting a sawmill into an ironworks called the Brandywine Iron Works and Nail Factory. This would be the birth of Lukens Steel.

Issac Pennock's daughter Rebecca married Dr. Charles Lukens in 1813. However, after his untimely death in 1825 at the age of 39, Rebecca Lukens took over the mill while raising young children with another on the way. Rebecca successfully operated the mill until 1840, marking her place in history.

As Lukens grew, so did Coatesville. Churches were built, businesses popped up along US Route 30, and neighborhoods were established, building the community. In 1867, Coates Villa and the Village of Midway joined to form the Borough of Coatesville. In 1915, by a majority vote of its citizens, Coatesville became the first and only city in Chester County.

By the mid-1900s, Coatesville was filled with stores, hotels, restaurants and even a radio station, WCOJ 1420AM, "The Voice of Chester County," could be found within the city, along with a YMCA and a movie theater. At Christmastime, Santa waited patiently at the corner of Third Avenue and Lincoln Highway for children to arrive with their lists and sit on his lap.

By the 1970s, shopping malls, big-box stores, and the construction of the Route 30 bypass took consumers away from the downtown businesses, which in turn affected the city's real estate market. But much has changed since then.

Over the past 15 years, many good changes have come to Coatesville, and there are more on the horizon.

Habitat for Humanity has built brand-new homes along Oak Street, making it possible for first-time buyers to become homeowners.

The Coatesville Sports Hall of Fame was formed in 2000 to honor former students of Coatesville Area High School who had excelled in school sports, demonstrated overall good citizenship, brought honor to their school, and were a source of pride to the community.

The Brandywine Health Foundation was formed as a public charity in 2001, awarding grants and scholarships, building the Brandywine Center (a health and housing center), and launching the Coatesville Youth Initiative to address the broader health needs of young people, as well as successfully taking over the Brandywine Strawberry Festival, an annual four-day event that benefits the Coatesville community in numerous ways.

The Western Chester County Chamber of Commerce (formerly the Coatesville Chamber of Commerce) was resurrected from near extinction and has now become one of the fastest-growing chambers in the county.

The Coatesville Christmas Parade continues to march down Main Street every year on the first Saturday of December, bringing out hundreds of spectators to line the streets and watch as Philadelphia Mummers string bands, sports mascots, school bands, groups, and floats pass by, bringing cheer and goodwill to all in attendance.

The National Iron and Steel Heritage Museum has been established. In 2010, it brought 500 tons of Lukens steel back to its home in Coatesville after it was literally the only thing standing after the attacks on the World Trade Center in New York on 9/11.

The year 2015 commemorates Coatesville's 100th anniversary of becoming a city—the only city in all of Chester County. On April 15, 2015, Coatesville Centennial kicked off a year-long celebration at the original Coatesville Train Station at Fleetwood Street and Third Avenue, complete with special guests, music, refreshments, and, above all, new beginnings for Coatesville.

One

HAPPY DAYS

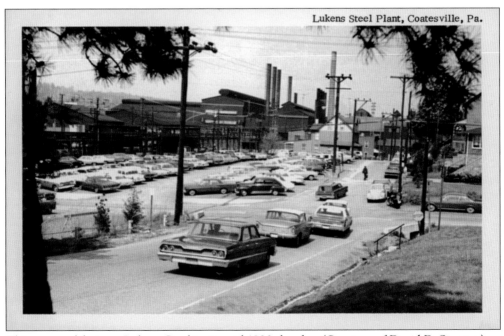

This postcard features Lukens Steel in its mid-1900s heyday. (Courtesy of David DeSimone.)

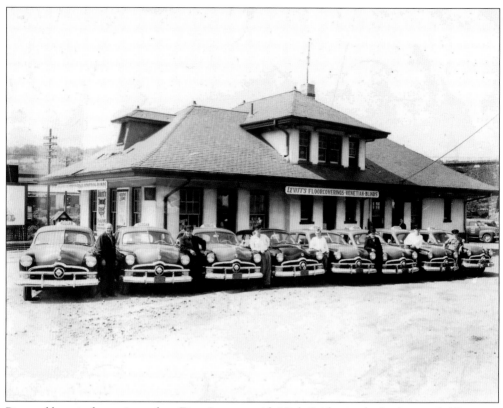

Pictured here is the taxi stand on First Avenue, with High Bridge in the background. (Courtesy of the Coatesville Flower Shop and the DePedro family.)

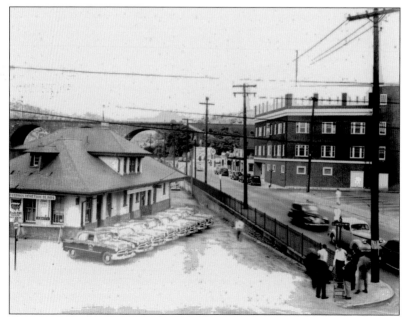

Here is another view of the taxi stand on First Avenue. (Courtesy of the Coatesville Flower Shop and the DePedro family.)

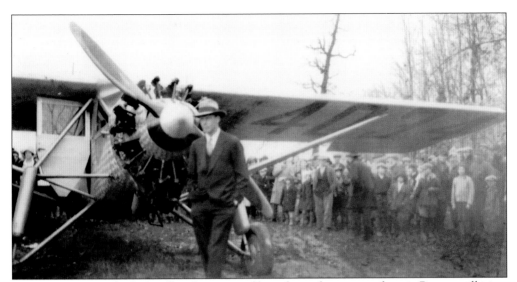

American aviator Charles Lindbergh is pictured here during his stay at a farm in Romansville, just outside of Coatesville. He was known as the Lone Eagle, and a street in the area was named Lone Eagle Road in his honor. (Courtesy of the Coatesville Flower Shop and the DePedro family.)

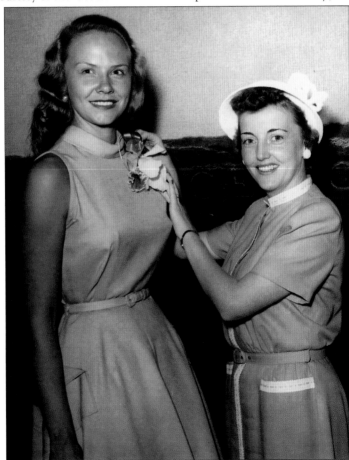

Miss America 1954, Evelyn Ay of Ephrata, Lancaster County, is pictured here with Coatesville Flower Shop's Peggy DePedro. As of this writing, since Ay's win, there has not been another Miss America to hail from the state of Pennsylvania. (Courtesy of the Coatesville Flower Shop and the DePedro family.)

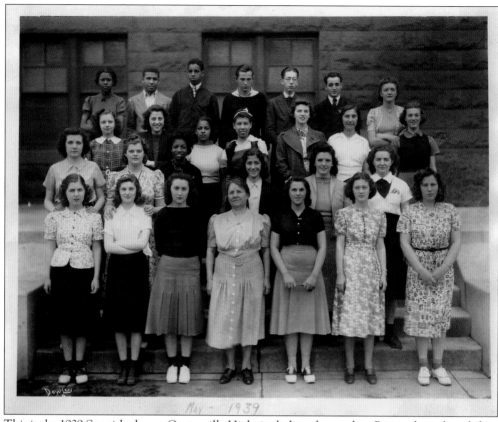

This is the 1939 Spanish class at Coatesville High, including the teacher. Pictured are, from left to right, (first row) Sara Sharp, Mildred Rea, Sue Rubincam, Miss ? Lechner, Emma Whitman, Betty Watson, and Verna Hoffman; (second row) Catherine Nash, Virginia Williams, unidentified, Louise Vietri, Rita Monaghan, and Sara Langford; (third row) Dorothy Reiter, Betty Russell, Corrine Young, Lulu Long, Lorraine Rutter, Josephine Zazo, and Dorothy Law; (fourth row) Gladys Ben, unidentified, Gilbert Parker, Franklin Howe, unidentified, Howard Allen, unidentified. (Courtesy of the Coatesville Flower Shop and the DePedro family.)

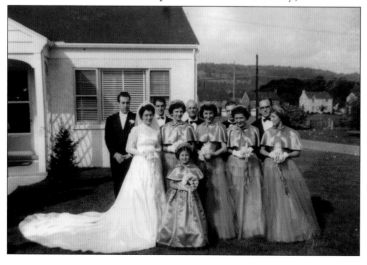

Pictured here is the party of a 1950s wedding that took place in Coatesville. (Courtesy of David Ficca.)

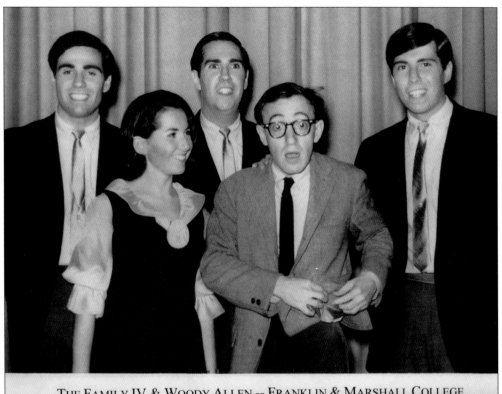

THE FAMILY IV & WOODY ALLEN -- FRANKLIN & MARSHALL COLLEGE

The Horowitz family—from left to right, Alan, Susan, Fred, and Rudy—poses with Woody Allen (fourth from left). (Courtesy of the Coatesville Flower Shop and the DePedro family.)

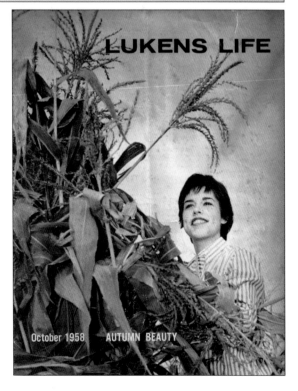

Here is the cover of a 1958 issue of *Lukens Life* magazine, which was published monthly by the public relations division of industrial relations for Lukens Steel Company. *Lukens Life* was for the employees and their families, shareholders, and friends. Its aim was to foster a spirit of unity in Lukens to help build a better company. (Author's collection.)

13

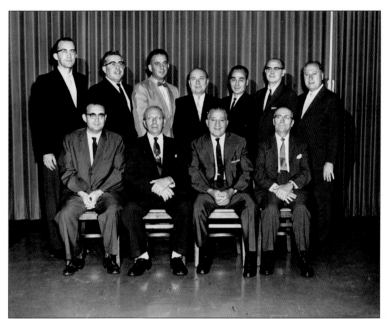

Pictured here are officers and trustees of the Loggia Goffredo Mameli (L.G.M.). They are, from left to right, (first row) Dan DiMichael, Nick Porecca, John Teti, and Manfredi Sabellico; (second row) Jim Donato, Sam Filoromo, Armond "Bull" Vietri, Mario Sabellico, Joseph Pilotti, Tony Donia, and Nick Rambo. (Courtesy of Dennis O'Neill.)

This is another group shot of officers and trustees of the L.G.M. Pictured are, from left to right, (first row) Joseph Pilotti, Albert DePedro, John Teti, John Rambo, and Joe "Joe Baggs" deChristophoro; (second row) Lou Pilotti, a Mr. Pelligrino, Bill Porecca, Al Teti, and Richard "Biddy" DelGrande. (Courtesy of Dennis O'Neill.)

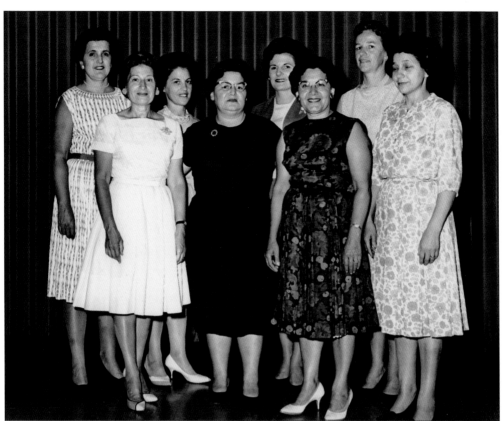

Members of the L.G.M. Ladies Executive Board pictured here are, from left to right, (first row) Josephine Rambo, Asunta Pilotti, and Angie Filoromo; (second row) Vera Higgins, a Mrs. Frederick, Elizabeth Vietri, and Sara Donia. (Courtesy of Dennis O'Neill.)

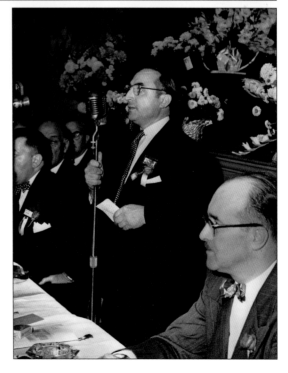

Joseph "Joe Bags" deChristophoro speaks during a banquet at the L.G.M. (Courtesy of Dennis O'Neill.)

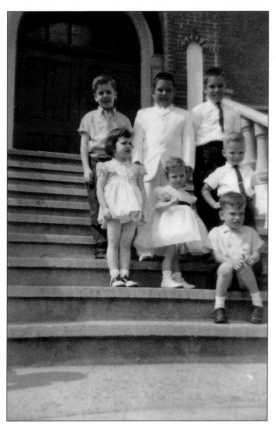

Cousins pose for a photograph on the steps of the former Our Lady of the Rosary Church on Coates Street during the early 1960s. Pictured are (first row) David Ficca; and from left to right, (second row) Mary Ann Hume-Rawls, Kathy Collins-Hanthorne, and Greg Collins; (third row) Larry Hume, Raymond Ficca, and Tom Ficca Jr. (Courtesy of David Ficca.)

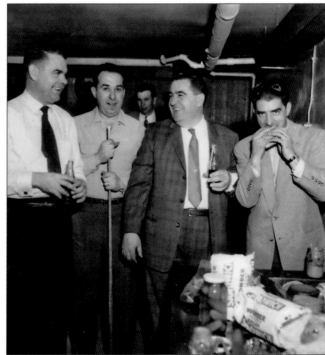

Unidentified friends are having a good time in the L.G.M. clubroom in the 1950s. (Courtesy of David Ficca.)

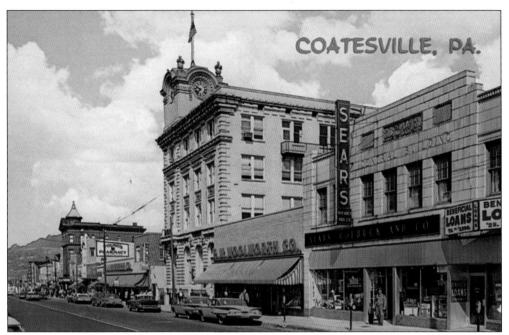

This postcard depicts Coatesville as it appeared in the 1960s. (Courtesy of David DeSimone.)

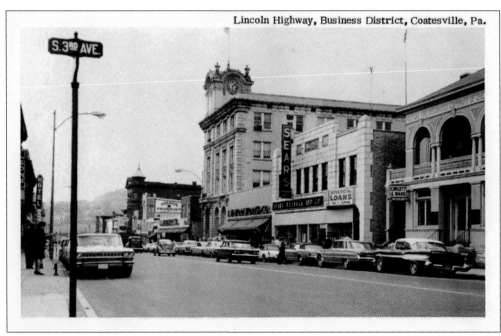

The intersection of Route 30 and Third Avenue is in the heart of Coatesville. (Courtesy of David DeSimone.)

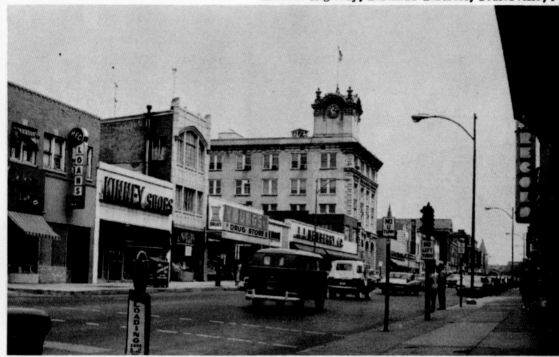

The intersection of Route 30 and Third Avenue is in the heart of Coatesville. The *Coatesville Record* newspaper offices, Kinney Shoes, and the J.J. Newberry store can all be seen in this photograph. (Courtesy of David DeSimone.)

Two

PLACES REMEMBERED

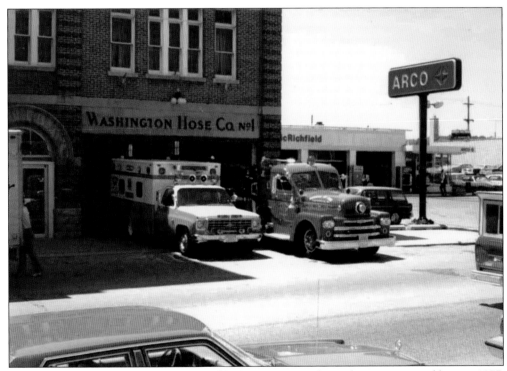

Washington Hose Co. No. 1, in the 300 block of East Lincoln Highway, is pictured here in 1977. This building is now an apartment complex, and the fire company is now located down the street at East Lincoln Highway and Fourth Avenue. (Courtesy of Joyce L. Ford.)

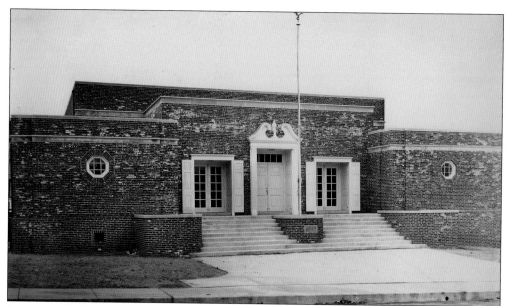

Loggia Goffredo Mameli No. 193 (L.G.M.) was organized on July 6, 1913, and incorporated on August 10, 1913. Founders were Gioacchino Cotone, Frank Rambo, and Frank Pettineo. In the early days, meetings were held in various places around the city, until this building located at 28 Chester Avenue was erected in 1949. (Courtesy of Dennis O'Neill.)

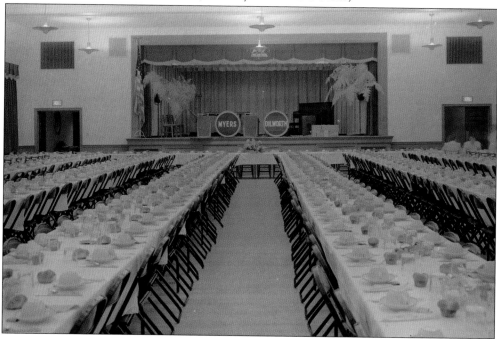

The brand-new ballroom in the L.G.M. is seen before the dedication dinner in 1950. For the next 55 years, weddings, dances, dinners, anniversaries, fundraisers, and many other events would be held in this hall, the largest in the Coatesville area. The L.G.M. was a Sons of Italy club with a private members-only area on the lower level and a banquet hall on the upper (street) level. (Courtesy of Dennis O'Neill.)

The members-only club room in the basement of the L.G.M. is pictured here when it first opened in 1949. (Courtesy of Dennis O'Neill.)

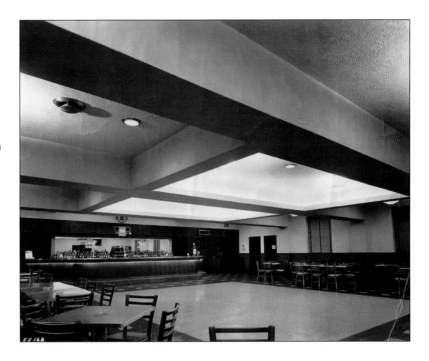

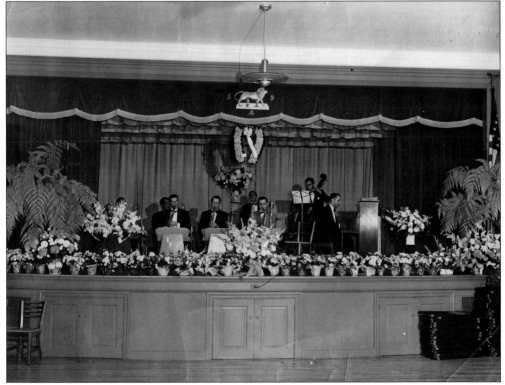

The Tom Donohue Orchestra is performing on stage in the L.G.M. Ballroom. Identified in this photograph are Tom Donohue (tenor sax), Pete Duca (drums), Neals Olsen (piano), Oscar Moore (bass), and Clarence Miller (sax).

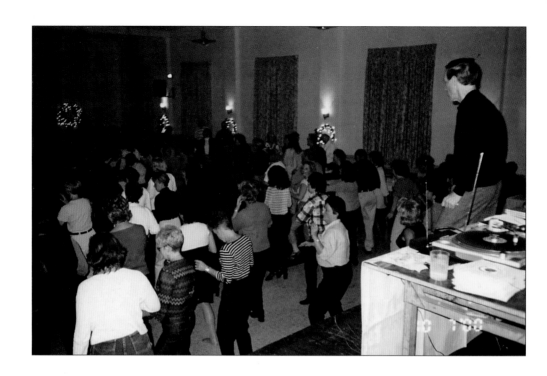

Philadelphia-based disc jockey Jerry Blavat gets the crowd moving during an appearance at the L.G.M. in 2000. (Both, author's collection.)

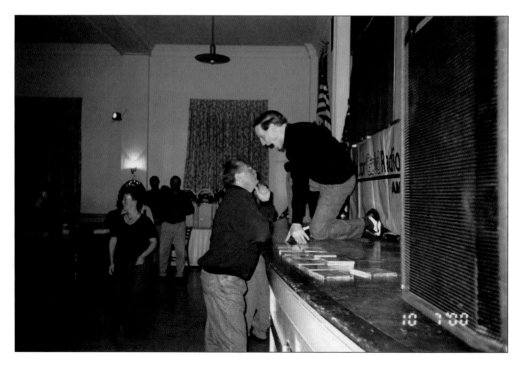

Jerry Blavat (left) poses with L.G.M. president Joe DePaolantonio in 2000 during one of his many appearances at the L.G.M. (Author's collection.)

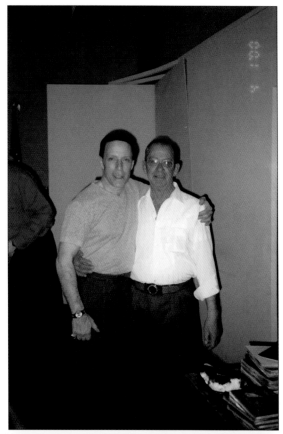

Around 1999, L.G.M. staff prepare to work one of the many banquets held at the popular hall over the years. Pictured are, clockwise from bottom left, Joe DePaolantonio, Anthony Frederick, Jr., Marie Slody, and Angela Frederick. (Author's collection.)

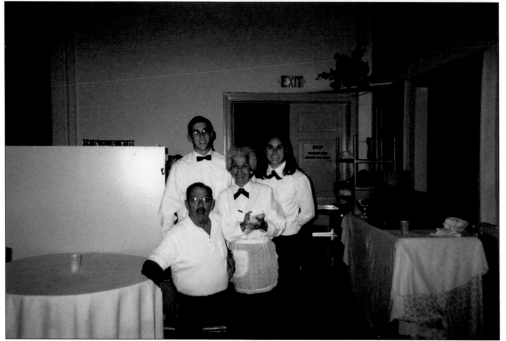

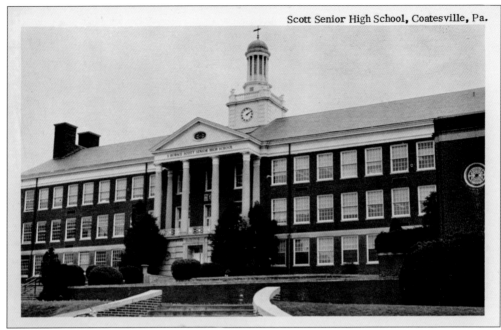

Scott Senior High School, Coatesville, Pa.

S. Horace Scott Senior High School is featured on this postcard, with a photograph taken before the Coatesville Area Senior High (C.A.S.H.) was built. (Courtesy of Jay Byerly and David DeSimone.)

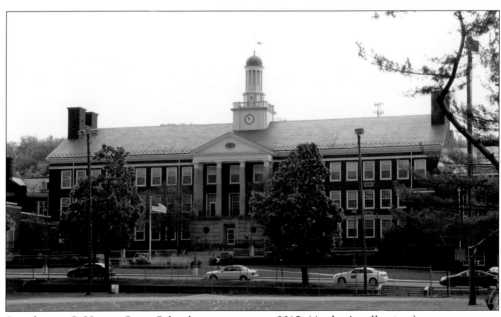

Seen here is S. Horace Scott School as it appears in 2015. (Author's collection.)

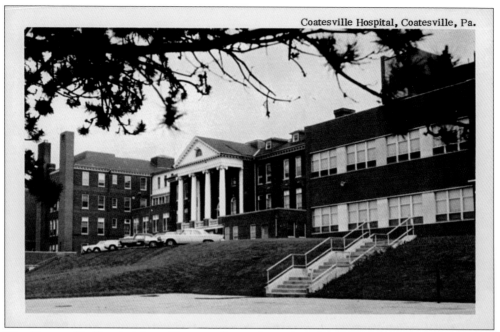

The Coatesville Hospital (now Harrison Senior Living) on Strode Avenue is featured on this postcard. (Courtesy of Jay Byerly and David DeSimone.)

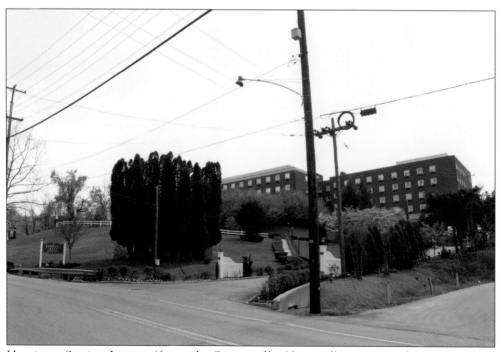

Harrison Senior Living (formerly Coatesville Hospital) is pictured here in 2015. (Author's collection.)

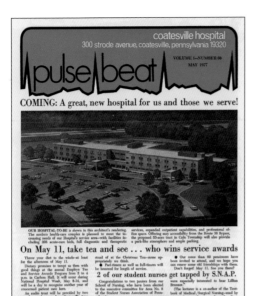

A 1977 newsletter from the former Coatesville Hospital includes a rendering of the future Brandywine Hospital, which opened in 1980. (Courtesy of the Brandywine Health Foundation.)

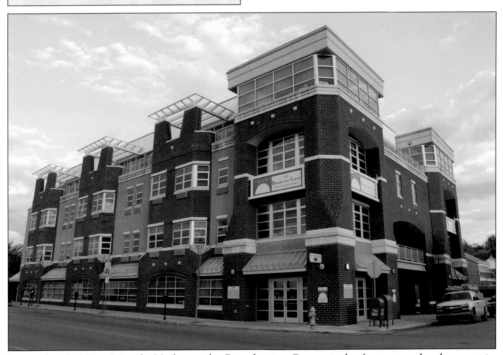

Located at 744 East Lincoln Highway, the Brandywine Center is the first major development in Coatesville in over 30 years. Opening in 2008, the Brandywine Center serves as a center for primary health care services, dental care, and behavioral health for residents throughout the county and houses 24 affordable apartments for senior citizens. With leadership from elected officials and government leaders from the county, city, and commonwealth, a variety of financing entities, foundations, and generous individuals provided support for the Brandywine Health Foundation's efforts to bring this important development to fruition. (Author's collection.)

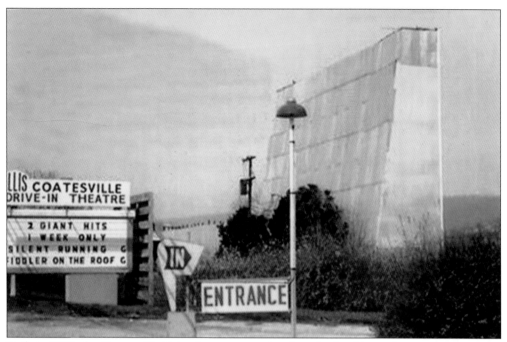

Built in 1950, the Coatesville Drive-In was a popular place for families and teenagers to enjoy a fun night out. Located at 2700 East Lincoln Highway, the drive-in closed in the mid-1970s and the site is now home to Barley Station, a strip mall. (Courtesy of Kenny Lennon.)

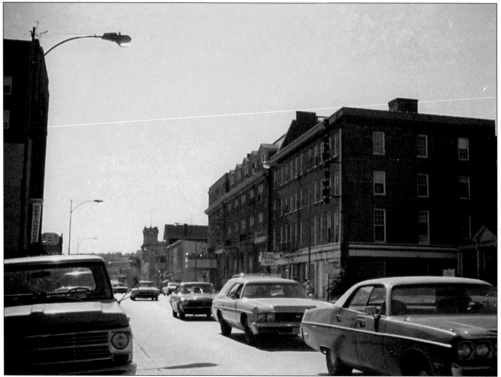

Business Route 30 is pictured here in the 1970s. (Courtesy of Jay Byerly.)

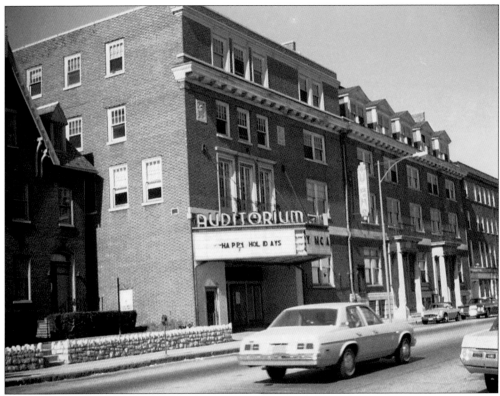

Business Route 30 is seen here again in the 1970s. (Courtesy of Jay Byerly.)

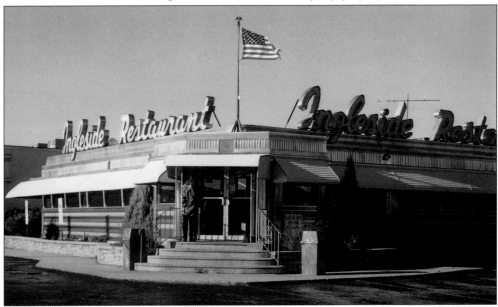

The Ingleside Diner (formerly Zinn's Diner) operated from 1956 to 2002 along Lincoln Highway in Thorndale, just east of Coatesville. Built by the Fodero Dining Car Company, the diner was outfitted in stainless steel with pink accents. (Courtesy of the Coatesville Flower Shop and the DePedro family.)

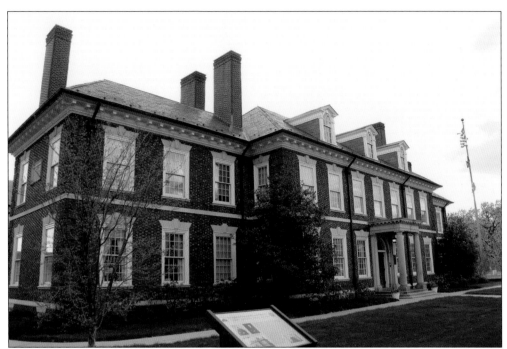

The Lukens Executive Building, located at 50 South First Avenue, was built in 1902–1903 under the direction of A.F. Huston to be the Lukens Steel Company headquarters. Date stones set in the south and north sides signify that Lukens Iron and Steel Company was founded in 1810, and construction of the office building began in 1902. Today, this beautiful building is home to the offices of the National Iron and Steel Heritage Museum, the Brandywine Health Foundation, and the Western Chester County Chamber of Commerce, among others. (Author's collection.)

Terracina was built in 1850–1851 by Rebecca Lukens for her daughter Isabella Lukens Huston and son-in-law Dr. Charles Huston. This Huston homestead remained a family residence until 1985. Terracina is located next to the Lukens Executive Building, across the street from the Graystone Mansion, and is available for guided tours. (Author's collection.)

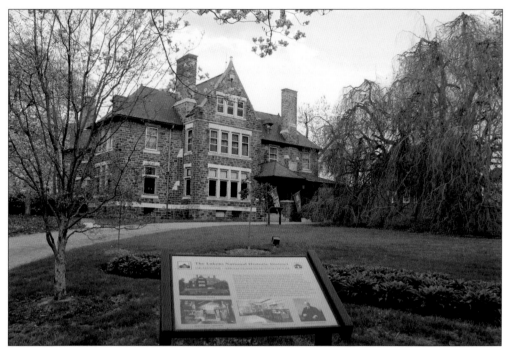

Graystone Mansion is located across from the Lukens Executive Building and was once the home of Abram Francis Huston, who succeeded his father, Dr. Charles Huston, as president of Lukens Iron and Steel Company in 1897. Graystone was later used as city hall and the police station. Today, this architecturally significant structure is used for special events (on the first floor) and houses Harcum College on the second floor. Graystone is part of the National Iron and Steel Heritage Museum and is available for guided tours. (Author's collection.)

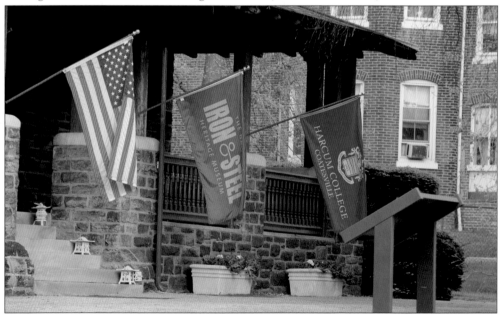

The front porch of Graystone Mansion proudly displays the American flag, a National Iron and Steel Heritage Museum flag, and Harcum College's flag. (Author's collection.)

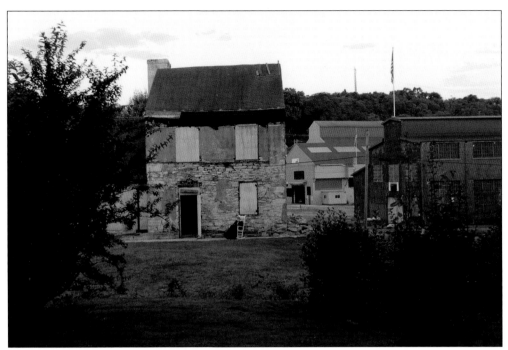

Rebecca Lukens (portrayed by Susannah Brody), America's first female industrialist, sits in her rocking chair outside of historic Brandywine Mansion, which was her home in the 1800s. The home is currently being restored; in March 2015, workers found letters addressed to Lukens tucked away in a wall. A very important discovery for the National Iron and Steel Heritage Museum, the oldest letter is dated 1814, while 15 of the 20 letters recovered were written in the spring and summer of 1834. Lukens ran the mill after her husband, Charles Lukens, died in 1825. (Author's collection.)

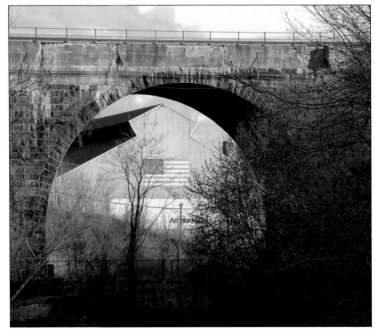

ArcelorMittal (formerly Lukens Steel) is seen through one of the arches of the High Bridge on Route 82. (Author's collection.)

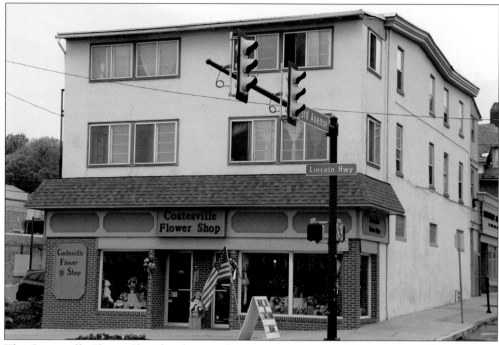

The Coatesville Flower Shop has been in business since 1948 and continues to thrive almost 70 years later. Originally located at 334 East Lincoln Highway, the flower shop moved to its present location at the corner of Third Avenue and East Lincoln Highway in 1977. Proudly owned and operated by the DePedro family, founded by patriarch Carmen and his wife, Peggy, the shop is now run by their son Greg and his wife, Dorrie, as well as many faithful employees. (Author's collection.)

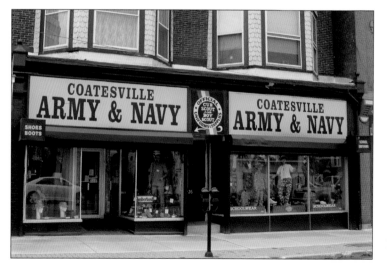

Located at 228 East Lincoln Highway, the Coatesville Army & Navy Store has been serving generations of local shoppers for over eight decades. Owned and operated by the Skolnik family, the store continues to be a destination for many who appreciate quality merchandise and personalized service. (Author's collection.)

Three

COATESVILLE
CHURCH TOUR

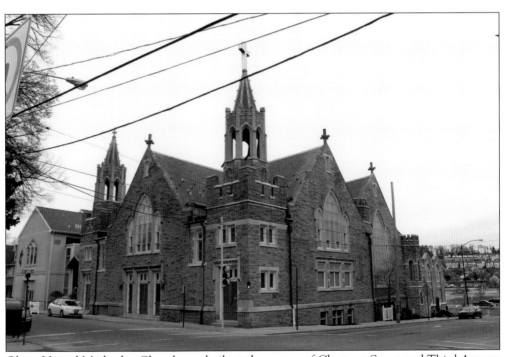

Olivet United Methodist Church was built at the corner of Chestnut Street and Third Avenue in 1885. The first Methodist Society in Coatesville was established in 1817 in a schoolhouse on the corner of Third Avenue and Harmony Street. A local preacher, Alban Hook, is credited with preaching the first sermon in Coatesville. (Author's collection.)

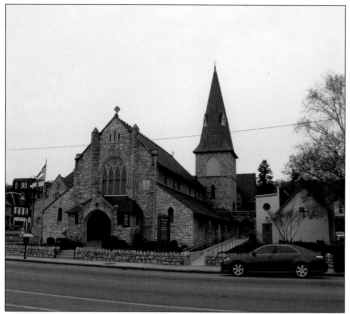

Episcopal Church of the Trinity, located at 323 East Lincoln Highway, was built in 1870. The first service was held in a schoolhouse at the corner of Third Avenue and Lincoln Highway (or Main Street) in 1859. Since Coatesville was not an organized parish at the time, the Reverend John B. Henry of Downingtown officiated that first service. In October 1868, Rev. George G. Field became the first resident pastor, and the Episcopal Church of the Trinity was formally founded. (Author's collection.)

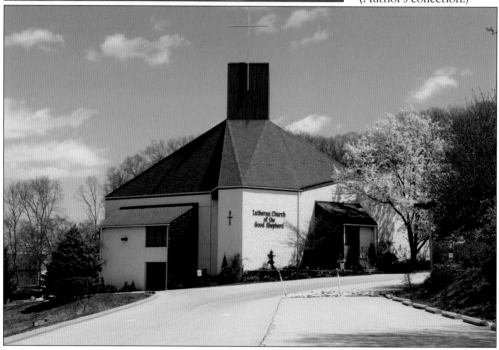

Dedicated on September 15, 1974, the Lutheran Church of the Good Shepherd was formed as a result of two churches joining together. In June 1890, Trinity Lutheran Church was officially organized, and the original church was located at the corner of Church Street and Lincoln Highway. To accommodate the quickly growing congregation, a second church, the Evangelical Church of Our Savior, was built in 1909 at the corner of Fifth Avenue and Chestnut Street. As both churches continued to grow, it was decided to come together and build a church big enough to accommodate both, and the Lutheran Church of the Good Shepherd was formed. (Author's collection.)

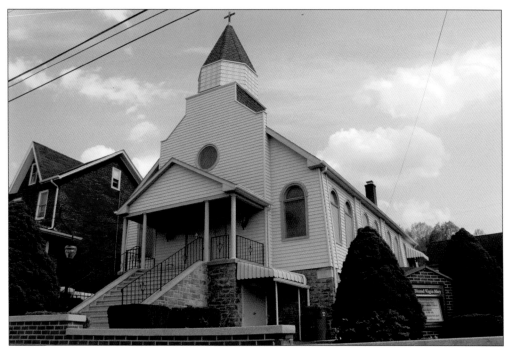

Tucked away at the corner of Strode Avenue and Gap Road is Blessed Virgin Mary Byzantine Catholic Church. Around the turn of the 20th century, a group of Hungarian Catholics settled in Coatesville. Initially attending services in other Byzantine Rite churches, the group resolved to form its own parish. Construction began in 1918, and on Sunday, May 4, 1919, the Very Reverend Michael Balog, dean of Cleveland, Ohio, officiated the blessing of the church. (Both, author's collection.)

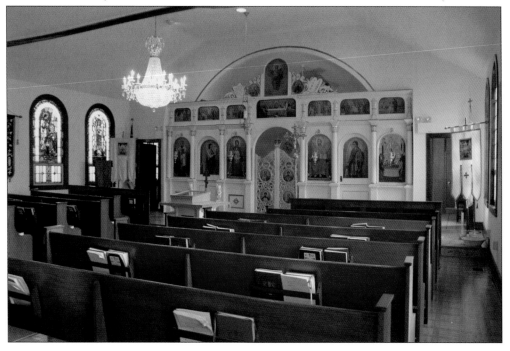

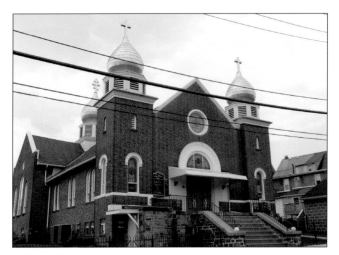

Holy Ghost Ukrainian Orthodox Church was founded in 1909 by W. Wolownik, H. Mokry, W. Kozachshyn, and Illa Lukasewych. Organized services were originally held in their homes, but with the growing number of attendees, it was necessary to erect a church building. The first church was on Gibbons Street, but the congregation quickly outgrew the sanctuary. In 1917, the current church, which stands at 392 Charles Street, was built. (Author's collection.)

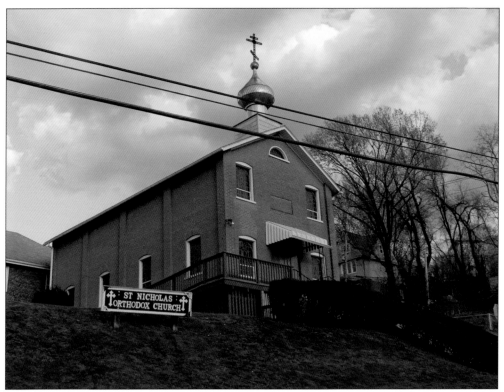

In the early 20th century, Russian immigrants seeking work at the steel mill settled in Coatesville. At the time, the nearest Russian Orthodox church was in Philadelphia. Desirous of a place to worship close to home, the Russian Orthodox Parish of St. Nicholas, with 119 founding members, was organized in 1915–1916 with the blessing of Archbishop Evdokim. Founding priest Fr. Vasily Kurdiumoff held services first in parishioners' homes and later in a rented building on Third Avenue next to the railroad station. In 1917, land was purchased at First Avenue and Oak Street, where the cornerstone of St. Nicholas Orthodox Church was blessed by Archbishop Alexander; the church was completed the same year. (Author's collection.)

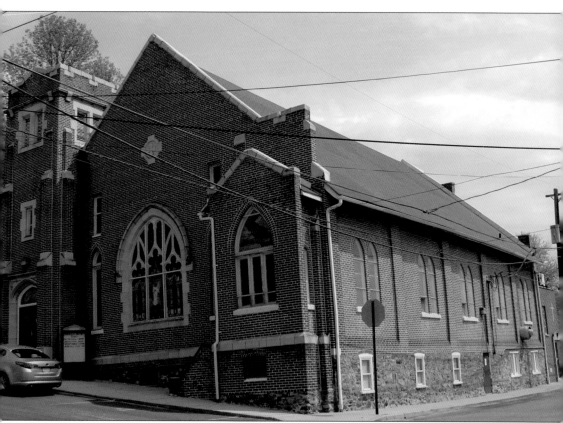

Tabernacle Baptist Church, founded by Reverend Alexander in October 1907, is located at 819 Coates Street. As the congregation was growing rapidly, an additional lot was purchased in 1917, and the original church was dismantled. The new church was built in 1918 and continues to be an important presence in the Coatesville community. (Author's collection.)

The Sisters of the Immaculate Heart of Mary (IHM) began teaching the children in the community in 1907 and continue to do so to this day at Pope John Paul II Elementary (on Route 82). St. Cecilia School (above) was a part of Coatesville Area Catholic, serving children from kindergarten to fourth grade until 2007, when Pope John Paul II Regional Elementary School (below) was built. (Both, author's collection.)

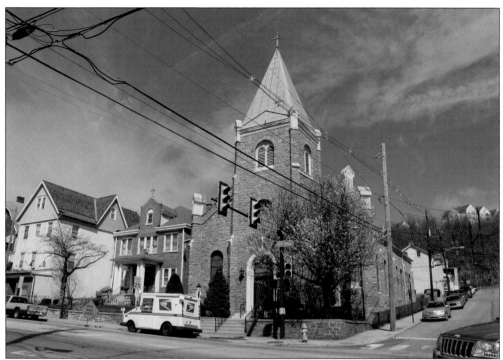

St. Stanislaus Kostka Parish was founded in 1907 and modeled after churches found in Poland, from which the majority of the congregants had emigrated. St. Stanislaus Kostka Catholic Church (above) was named after 16th-century saint Stanislaus Kostka, who entered the priesthood as a teenager and was canonized after his death at the age of 18. Today, St. Stanislaus operates as a worship site and is closed for regularly scheduled masses. Completed in 1874, St. Cecilia Church (below) is located at Sixth Avenue and Chestnut Street. Like St. Stanislaus, St. Cecilia now operates as a worship site. (Both, author's collection.)

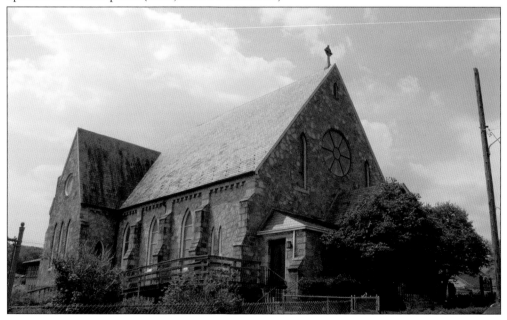

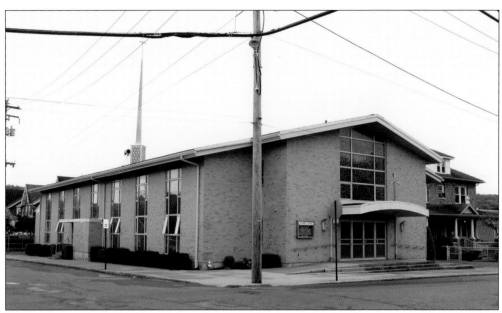

St. Joseph's Parish is located at 404 Charles Street. St. Joe's was formed by a division of St. Stanislaus Parish (which consisted of both Polish and Slovak citizens) in 1924. Prior to St. Stanislaus, St. Cecilia Church was the only Catholic church in Coatesville. Initially, church services were held in the Smith Garage (now the Polish-American Club on Strode Avenue). In 1926, construction began at the corner of Hope Avenue and Charles Street of St. Joseph (Slovak) Catholic Church. The first services were held on Sunday, May 29, 1927. St. Joseph's School was part of Coatesville Area Catholic School (seventh and eighth grades) until 2007, when Pope John Paul II Regional Elementary School was built, serving students in prekindergarten through the eighth grade. (Both, author's collection.)

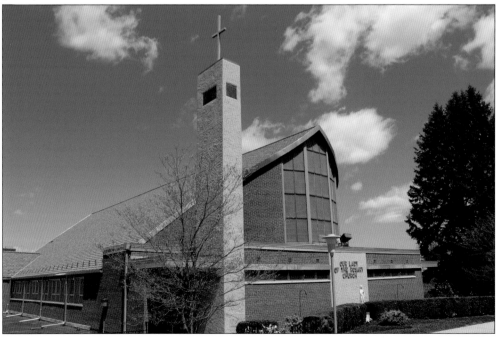

Our Lady of the Rosary Church, founded in 1917, was originally located at the corner of Coates Street (now the home of Holy Tabernacle Church of God in Christ). Although a new lot at the corner of Seventeenth Avenue and Oak Street was obtained in 1955, it was not until 1966 that the ground-breaking ceremony took place, and the new church was dedicated on September 17, 1967. (Author's collection.)

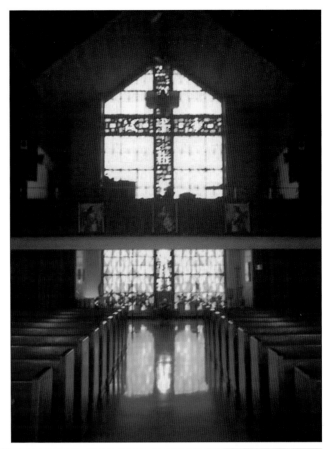

Holy Tabernacle Church of God in Christ (formerly Our Lady of the Rosary) is located at 533 Coates Street. (Author's collection.)

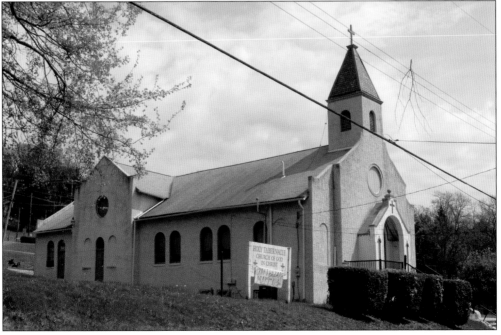

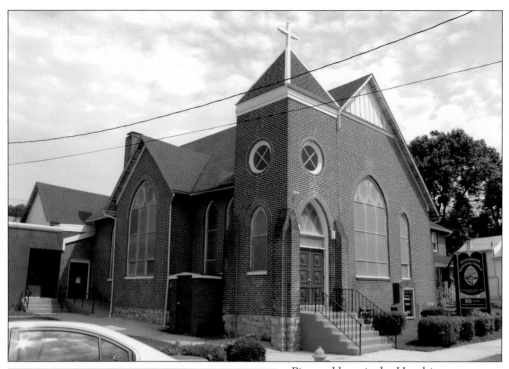

The James Adams School

Pictured here is the Hutchinson UAME Church. The Union Church of Africans was formed in Fallowfield, Pennsylvania, in 1820 by Rev. Peter Spencer. Reverend Spencer organized 31 churches in his lifetime and erected a schoolhouse with each church. The name was legally changed to the Union American Methodist Episcopal Church (UAME) in 1853. Rev. William W. Hutchinson became the pastor and in 1869 constructed a redbrick building at Sixth Avenue and Merchant Street. In 1908, construction began at 825 East Chestnut Street, and the first service was held on March 28, 1909. (Both, author's collection.)

Four

SPORTS

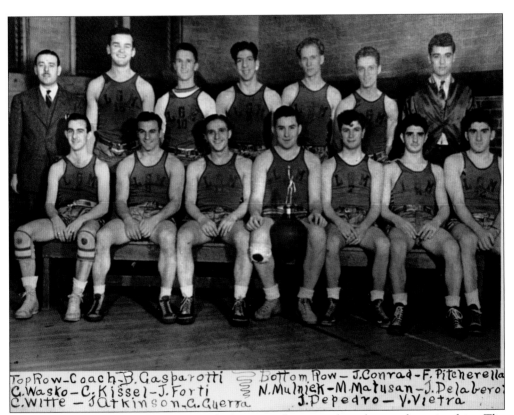

Top Row—Coach B. Gasparotti
C. Wasko—C. Kissel—J. Forti
C. Witte—J Atkinson—G. Guerra

Bottom Row—J. Conrad—F. Pitcherella
N. Mulnick—M. Matusan—J. Delabero
J. Depedro—V. Vietra

The 1942 L.G.M. basketball team won the bi-county league and city league championships. The team took the bi-county crown by defeating New Holland in a playoff at Gap, then defeated Cohen Brothers less then two weeks later for the city title. Pictured are, from left to right, (first row) Jack Conrad, Fred Pitcherella, Nate Mulnick, Mike Matusan, Jerry Deliberato, Albert DePedro, and Vince Vietri; (second row) coach Bruno Gasparotti, George Wasko, George Kissel, Joe Forte, Charlie Witte, Jim Atkinson, and manager Joe Guerrera.

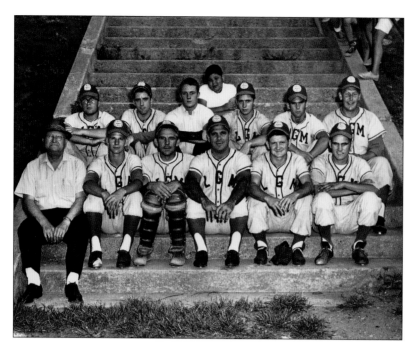

Pictured here in the 1950s is an L.G.M. baseball team. (Courtesy of Dennis O'Neill.)

This L.G.M. baseball team is posing in the clubroom. (Courtesy of Dennis O'Neill.)

Pictured here is a Coatesville baseball team in 1940s. (Courtesy of David Ficca.)

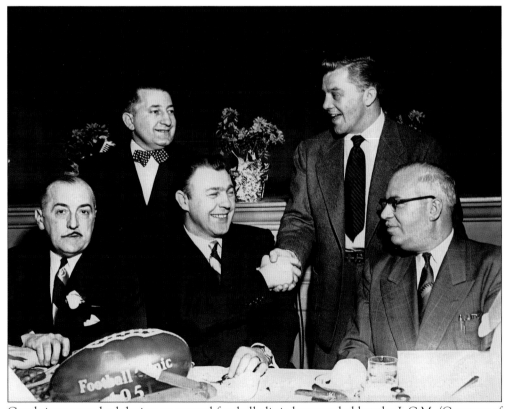

Good times were had during an annual football clinic banquet held at the L.G.M. (Courtesy of Dennis O'Neill.)

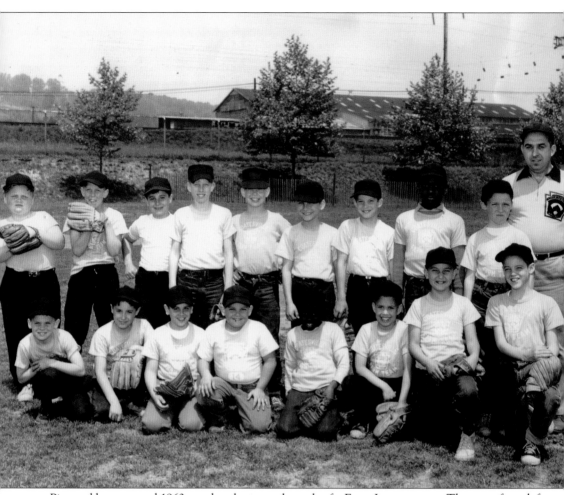

Pictured here around 1963 are the players and coach of a Farm League team. They are, from left to right, (first row) Jack McConnell, Albert Sardella, unidentified, Raymond Ficca, Jimmy Hill, Tom Ficca Jr., Ted Perpinka, and Vince DePaul; (second row) Jimmy Simmers, unidentified, John Sardella, two unidentified, Jimmy McInerny, Able Joe, Mike Luesky, unidentified, and coach Tom Ficca Sr. (Courtesy of David Ficca.)

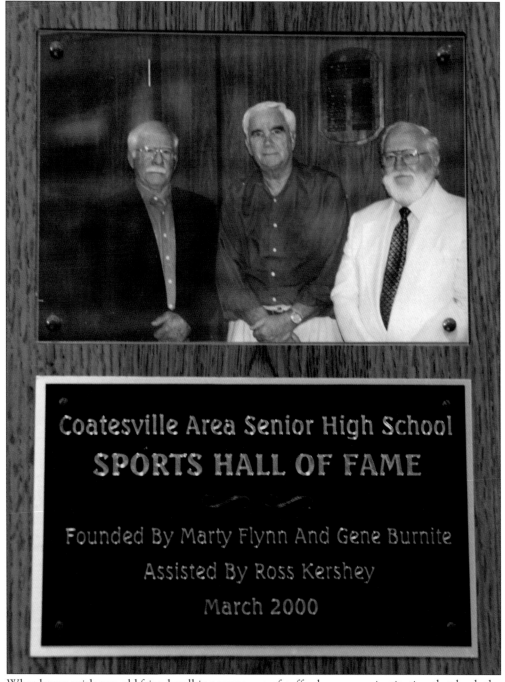

Coatesville Area Senior High School
SPORTS HALL OF FAME

Founded By Marty Flynn And Gene Burnite

Assisted By Ross Kershey

March 2000

What began with two old friends talking over a cup of coffee became an institution that lauds the best athletes Coatesville has to offer. The Coatesville Sports Hall of Fame has been recognizing exceptional athletes and coaches since 2000. Marty Flynn and Gene Burnite felt that former students of Coatesville Area High School who had excelled in sports and demonstrated overall good citizenship deserved a special recognition or acknowledgment. Thereafter, a committee was formed, and awards are given each year at a special banquet held in October. (Author's collection.)

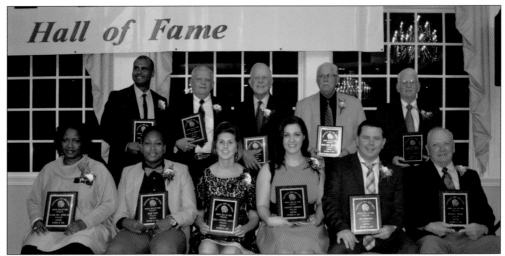

This image from the 2014 induction ceremony includes, from left to right, (first row) Linda Boynes-March, accepting for her brother William "Bill" Boynes (1977, track and field); Amber White (2006, basketball); Kelly O'Connell Liartis (2002, cross-country); Samantha Morrison (2002, softball); Rob Roberson (2002, cross-country); and "Ronnie" L. Moore (1961, baseball); (second row) Steven "Steve" Rutherford (1985, swimming); Wallace "Wally" H. Dering (1956, Old Timer's Award, swimming); coach Joseph A. Arasin (1962, golf); William Michael "Mike" Logue (1957, Old Timer's Award, track and field); and Warren L. Stackhouse III (Mac Stuber Memorial Award). Dick Denithorne (1954, Old Timer's Award, basketball; 1974, Special Team Recognition, Coatesville High School track and field) was also inducted that year. (Courtesy of the Coatesville Sports Hall of Fame.)

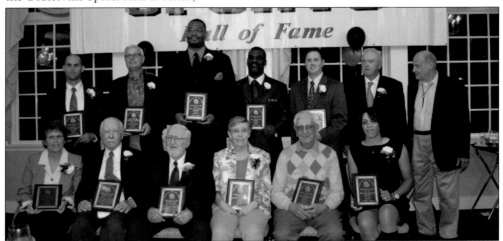

At the 2013 induction ceremony are, from left to right, (first row) Sharon L. Boyd (1978, softball); Martin "Marty" F. Flynn (1948, Founders Award); Gene Burnite (1947, Founder's Award); coach Rosalyn "Lyn" A. Greenlee (swimming, cross-country, track and field); Peter J. Marchiniszyn (1943, Old Timer's Award, football); and Theresa "Terri" Johnson-Lynch (1993, basketball); (second row) Matthew "Matt" Lapp (2001, cross-county); unidentified family member accepting for coach Quentin L. Deidrick (Mac Stuber Memorial Award; 1952, Special Team Recognition, Scott High School track and field); Martin "Marty" Eggleston (1985, basketball); Kevin M. Hunt (1979, football); Ryan Primanti (1996, baseball); Donald "Cy" Wilson (1953, Old Timer's Award, football, basketball, baseball); and unidentified. (Courtesy of the Coatesville Sports Hall of Fame.)

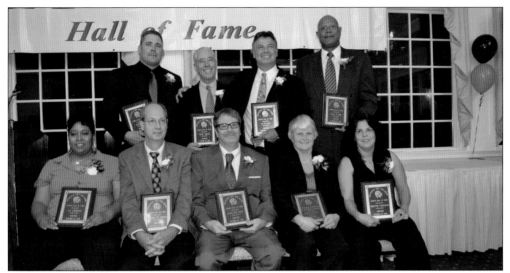

Pictured at the 2012 induction ceremony are, from left to right, (first row) Aja Anderson (1996, basketball); an unidentified family member accepting for coach D. Victor "Vic" Emanuel (Old Timer's Award; 1952, Scott High School basketball team, District 1 champions, Eastern Pennsylvania champions, Championship second place); Gavin "Scotty" Beam (1982, wrestling); Becky Layfield (1973, Mac Stuber Memorial Award); and Chris Tobelmann (1985, softball); (second row) Clint Seace (1984, football); Pete "Sonny" Gracia (1972, basketball); Ed Kovatch (1982, baseball); and Larry W. Lewis (1971, track and field). Kenneth H. Mateer (1923, Old Timer's Award, football, basketball) was also inducted. (Courtesy of the Coatesville Sports Hall of Fame.)

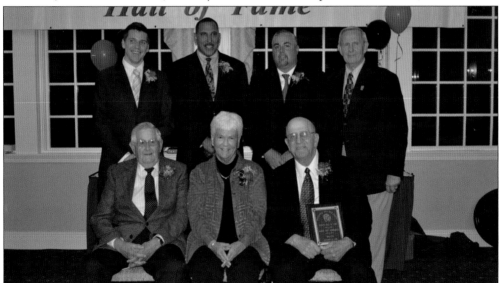

At the 2011 ceremony are, from left to right, (first row) Al Porta, accepting for his brother; Patsy LaPorte (Mac Stuber Memorial Award); Sharon Taylor (1962, softball, field hockey); and Albert "Bat" Mammarella (1942, football); (second row) Justin Donato (2000, swimming); Greg Blackwell (1980, football); Lance Ziegler (1997, baseball; 1943, Special Recognition, football); and Jack McCarter accepting for his son Steve McCarter (1978, basketball). Also inducted were Keenan Coleman (1994, track and field); Kierrah Marlow (2004, basketball), and Vic Pollack (1943, football). (Courtesy of the Coatesville Sports Hall of Fame.)

Hall of Fame

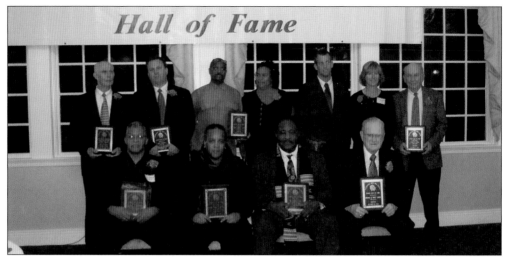

Pictured at the 2010 ceremony are, from left to right, (first row) Clifton L. Robinson (1966, track and field); Sacha "Socky" Gaffney (1990, basketball); Dr. John J. Joe (1955, football); and Marshall W. "Marty" Connor (1938, Old Timer's Award, basketball); (second row) coach Bill Richards (Mac Stuber Memorial Award); Richard "Rick" Primate (1989, soccer); John Munson and Carmen Allen, accepting for John "Tootie" Allen (2001, basketball); Dan D'Amato (1998, baseball); Rhonda Osborne Tredway (1985, softball); and Dave O'Leary. Also inducted was Clair A. Smith (1944, Old Timer's Award, tennis). (Courtesy of the Coatesville Sports Hall of Fame.)

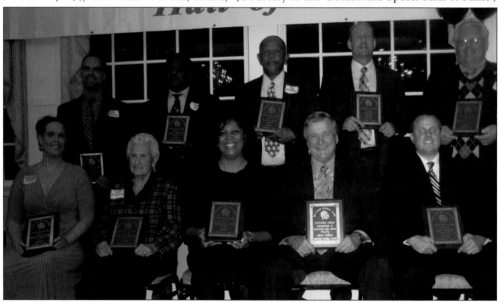

At the 2009 induction ceremony are, from left to right, (first row) Gretchen Lynott Gallagher (1995, swimming); Ruth DiObilda, accepting for her husband, Frank "Gink" DiObilda (1940s, football); Belinda Ben-Jones (1979, track and field); Chuck Carroll (Mac Stuber Memorial Award); and Marc Primanti (1992, soccer); (second row) Robert "Bob" Bonsall (1981, swimming); James "Jimmy" Joe (1970, football); Donnie Lawrence (1967, baseball); Dan Jones (1973, basketball); and an unidentified family member accepting for Harry G. Scott (former school board member and president). Also inducted was Ron Hunt (1974, track and field). (Courtesy of the Coatesville Sports Hall of Fame.)

The 2008 inductees include Robert
L. Urbine Jr. (1971, baseball),
Lindsay Fraschilla (1988, swimming),
Lewis P. Anderson (1945, football,
basketball, baseball), Ernie "Muff"
DiObilda (1949, football), James
Alderman (1960, football), Dolly
B. VanBuskirk Anderson (1974,
basketball), Gerald McGibboney
(1974, wrestling), Jesse Chalfant (1999,
cross-country, track and field), and
William "Pop" Ransom (Mac Stuber
Memorial Award). Lewis P. Anderson
is pictured here. (Courtesy of the
Coatesville Sports Hall of Fame.)

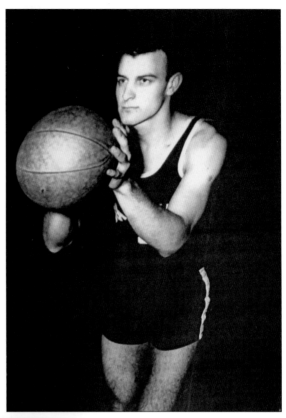

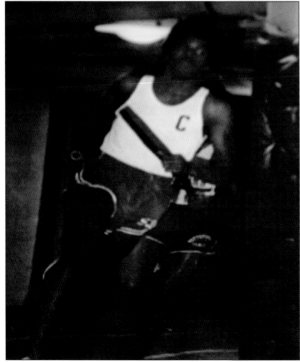

The 2007 inductees include
Solomon Hunter (1977, track
and field), Sue Ahern (1975,
softball), Nick DePedro (1944,
baseball), Barney Diehl (1940,
football), coach Maureen C.
Wallace, Barbara Ann (Detterline)
Wilson (1980, lacrosse), Darrel
Lewis (1994, basketball), William
Mendenhall Jr. (1961, baseball),
and Mark McWilliams (1982,
football). Hunter is pictured here.
(Courtesy of the Coatesville
Sports Hall of Fame.)

51

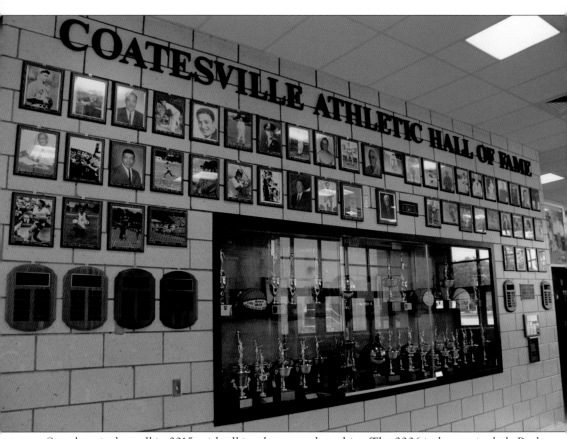

Seen here is the wall in 2015, with all its plaques and trophies. The 2006 inductees include Paul Rubincam Jr. (1951, basketball), Edward Horshock (1945, football), Leonard H. Patton Sr. (1938, baseball), Vince Vergara (1947, football), Doug Lewis (1974, track), Kinda Lewis (1999, volleyball), Charles H. Bock III (1995, swimming), Paul Hudson (1963, wrestling), David Weller (1976, cross-country), Edward D. Shultz (1984, football), and coach James "Scoogy" Smith, William Null (Special Award). The 2005 inductees include Tom Gomillion (1961, track and field), Charles "Derry" Baker (1943, football), Arthur H. Tooles Jr. (1982, basketball), coach Jeanne (Burns) Jarmoska (1970–1985), Karen Polak Farnum (1980, gymnastics), Gene Forte (1935, football, basketball, baseball), Alfred "Fred" Pitcherella (1939, football, basketball, baseball), John N. Entrekin Jr. (1934, basketball, baseball), A. Kenneth "Kenny" Hopton (1950, baseball), coach Mike Hemlock, John Warihay (1951, swimming), and Rosie DiSanctis (1982, basketball). (Courtesy of the Coatesville Sports Hall of Fame.)

The 2004 inductees include coach Renee Talley, Glenn Lewis (1962, track and field), Clara Dixon Davis (1974, softball), Lee Carter (1940, baseball), William "Billy" Morton (1939, track), coach Alvin F. Loomis, Mae Ladenberger Monetto (1929, basketball), Katie Nowak (1999, track and field), George Stanko (1949, basketball), Able Joe (1973, football), and coach Harry "Bud" Lewis Jr. The 2003 inductees include Don Ficca (1960, basketball), Carol (Haft) Renfrew (1980, tennis), John "Butch" Winters (1967, cross-country), David Lapp (1974, track and field), Robert H. McNelly (1931, football), Guy Griswold (1931, baseball), Nakeya Crutchfield (1988, track), Donald E. Wilkinson (1965, football), coach Joy B. Renfrew, and coach Allen "Al" Black. Harry Lewis Jr. is pictured here; he is currently a Pennsylvania state representative for the 74th District. (Courtesy of the Coatesville Sports Hall of Fame.)

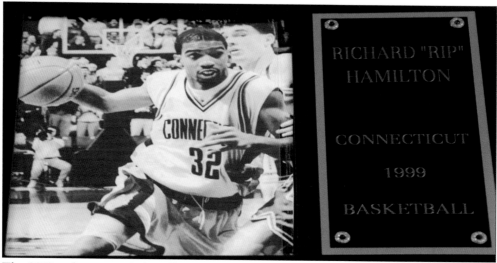

RICHARD "RIP" HAMILTON

CONNECTICUT

1999

BASKETBALL

The 2002 inductees include Billy Joe (1959, football), Terry L. Brown (1976, cross-country, track and field), James "Bubble" Lopp (1953, basketball), Patrice Trammell (1977, basketball), team physician Daniel Lee, MD, Augustine "Whisty" DeFroscia (football), Florindo "Beauty" DeMatteo (1936, football, basketball), Gregory Richard Jemison (1972, baseball), coach Leo "Acky" Atkinson, Linda Boynes March (1979, track and field), Dave Thorne (1957, swimming), Arthur "Ockie" Pollard (1952, track and field), and coach Ross Kershey. The 2001 inductees include coach Walt Funk, coach Bill Renfrew, Walt Downing (1974, football), Paul J. Chenger (1956, baseball), Terrence J. Williams (1966, wrestling), Mark Curlett (1974, golf), George T. Holms Jr. (1974, track), Colleen Cahill Smith (1986, hockey), Rose Gushanas (1988, lacrosse), Gail "Gussie" Brown (1955, basketball), and Richard "Rip" Hamilton (1996, basketball). (Courtesy of the Coatesville Sports Hall of Fame.)

The 2000 inductees include William Taylor Clinton (1949, swimming), coach Theodore "Ted" Daily (football), David Domsohn (1985, soccer), Bob Fleck (1949, football), Debbie Marshall (1975, softball), Herbert "Hubie" Marshall (1963, basketball), Gene T. Patton (1945, baseball), Rod Perry (1953, track and field), Sonya R. Perry (1989, track and field), Lynn Rawls (1990, basketball), and coach John Malcolm Stuber (1931). (Courtesy of the Coatesville Sports Hall of Fame.)

Five

COMMUNITY EVENTS

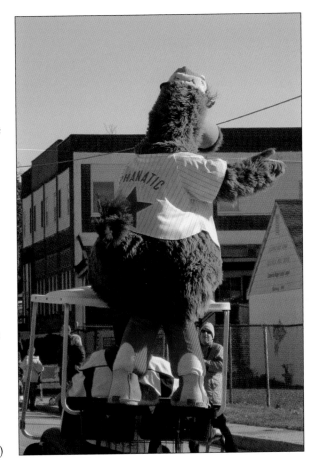

The Coatesville Christmas Parade was begun in the early 1970s by the Coatesville Jaycees. The parade was held yearly until the late 1980s, when the parade's core organizers turned 41 and were no longer eligible for membership in the organization. The parade passed into history—or so it seemed. Since 1994, the first Saturday in December has seen Coatesville's main street lined with thousands of spectators watching bands, floats, school groups, Cub Scouts, Brownie troops, antique and customized automobiles, fire trucks, clowns, and many others welcoming Santa and officially starting the holiday season. Seen here, the Phillie Phanatic, the Philadelphia Phillies' famous mascot, appears in a Coatesville Christmas Parade. The Phanatic has been entertaining fans since his debut at Veterans Stadium on April 25, 1978. He continues to perform at Citizens Bank Park and can be seen riding on his ATV and delighting fans, both young and young at heart. (Author's collection.)

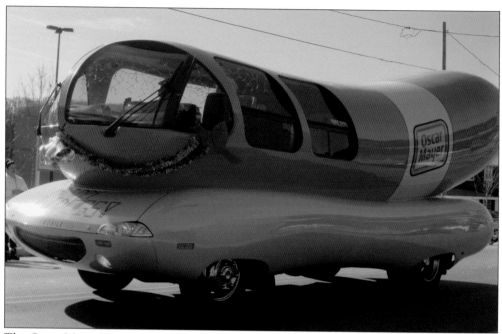

The Oscar Mayer Wienermobile appears in the 2012 Coatesville Christmas Parade. Evolving from Carl Mayer's original 1936 vehicle, the Wienermobile is 27 feet long and 11 feet high, with a horn the plays the well-known jingle. (Author's collection.)

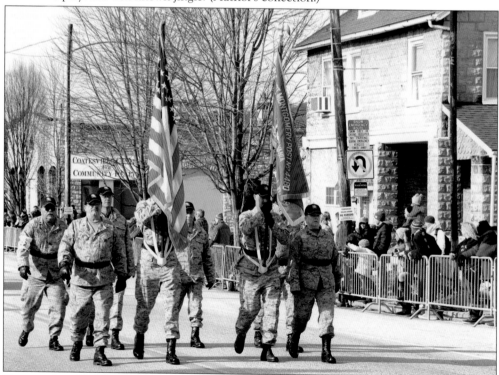

Veterans from local Veterans of Foreign Wars posts and surrounding communities lead the 2013 Coatesville Christmas Parade. (Author's collection.)

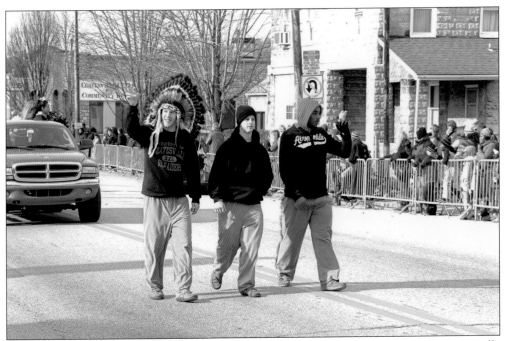

Coatesville High School's mascot, Chief Red Raider, and his braves appear in the 2013 Coatesville Christmas Parade. (Author's collection.)

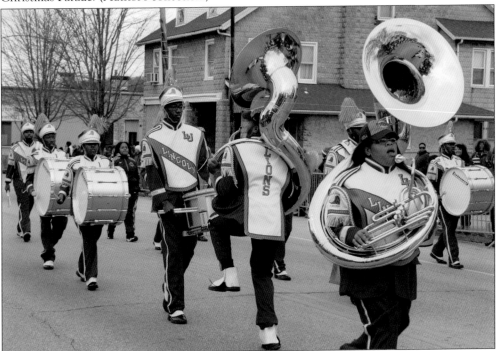

Lincoln University's marching band appears in a Coatesville Christmas Parade. Lincoln University opened a campus in Coatesville in 2013, utilizing the former Gordon Education Center at 351 Kersey Street. Lincoln is a historically black university located in southern Chester County. (Author's collection.)

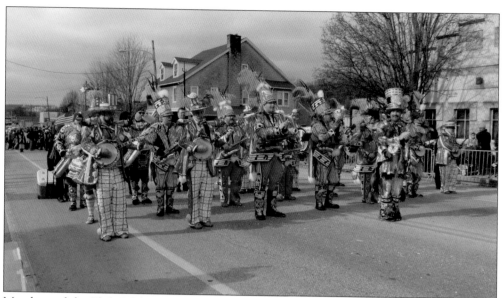

Members of the Philadelphia Mummers string bands have appeared in the 2013 Coatesville Christmas Parade for decades, much to the delight of the spectators. The string-band division is the musical highlight of the annual Philadelphia Mummers Parade held on New Year's Day. (Author's collection.)

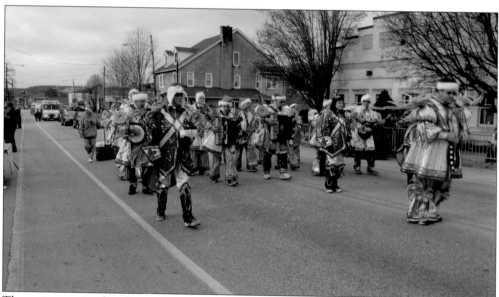

The unique string-band sound is comprised of saxophones, banjos, accordions, violins, bass fiddles, drums, and a glockenspiel. This combination of reed, string, and percussion has defined the sound for over 100 years. The band is pictured here in the 2013 Coatesville Christmas Parade. (Author's collection.)

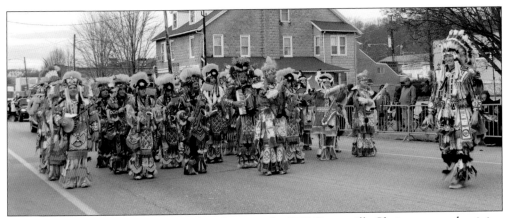

A Philadelphia Mummers string band performs in the 2013 Coatesville Christmas parade, giving spectators an up-close look at the members' festive costumes. (Author's collection.)

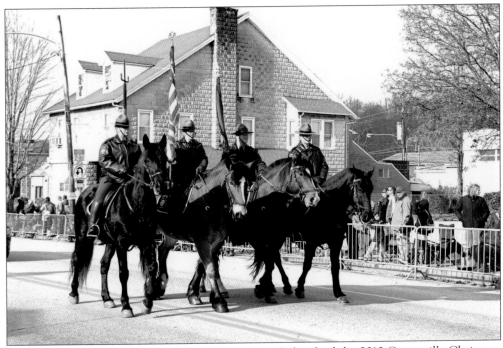

These members of the mounted Pennsylvania State Police lead the 2013 Coatesville Christmas Parade. (Author's collection.)

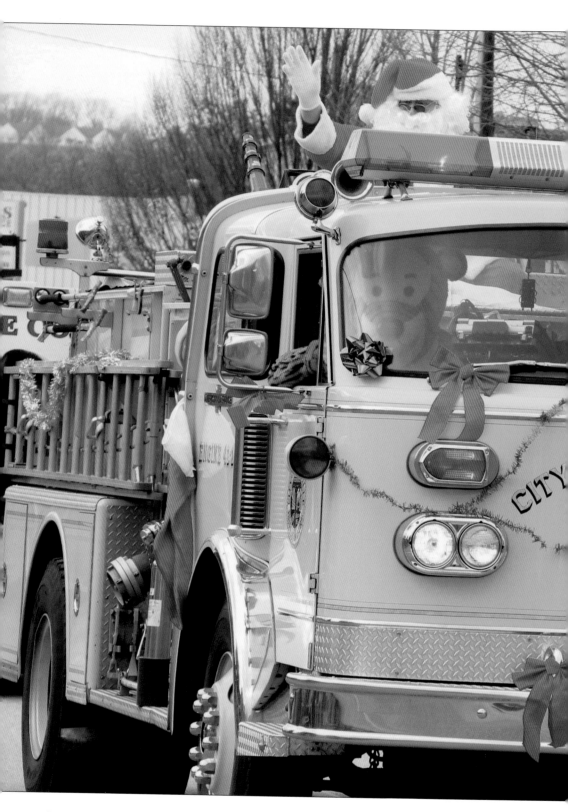

While riding on a Coatesville fire truck, Engine 41-1, Santa Claus waves to the spectators at the 2013 Coatesville Christmas Parade. (Author's collection.)

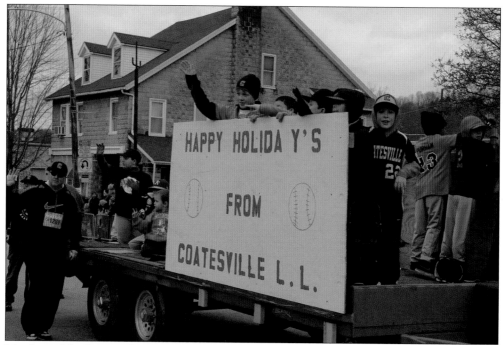

Members of the Coatesville Little League wave to the crowd from their float in the 2013 Coatesville Christmas Parade. The Coatesville Little League is a nonprofit organization, completely run by volunteers, and serves about 250 children between the ages of 4 and 16. The league is chartered by Little League Baseball. (Author's collection.)

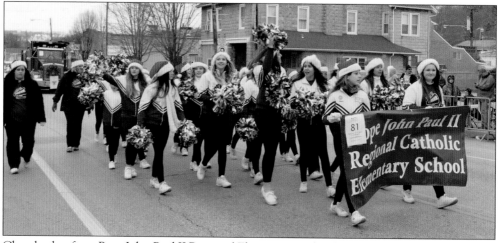

Cheerleaders from Pope John Paul II Regional Elementary School appear in the 2013 Coatesville Christmas Parade. (Author's collection.)

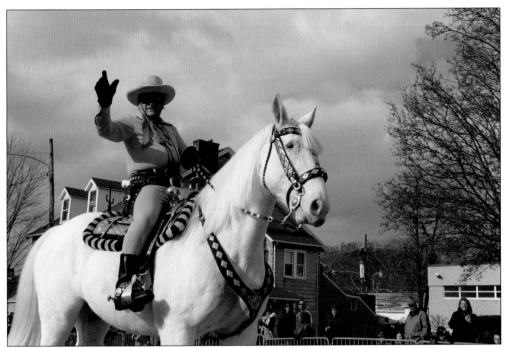

Another crowd favorite, the Lone Ranger and Silver are pictured in the 2013 Coatesville Christmas Parade. (Author's collection .)

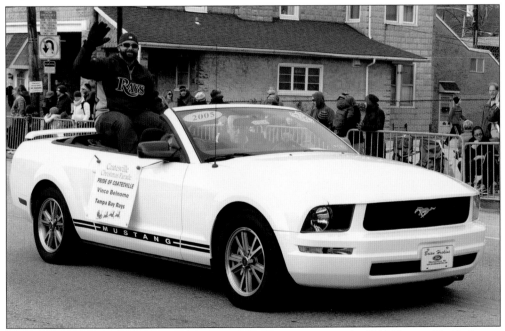

Coatesville native Vince Belnome of the Tampa Bay Rays appears in the 2013 Coatesville Christmas Parade. In 2015, Belnome plays for the New York Mets. (Author's collection.)

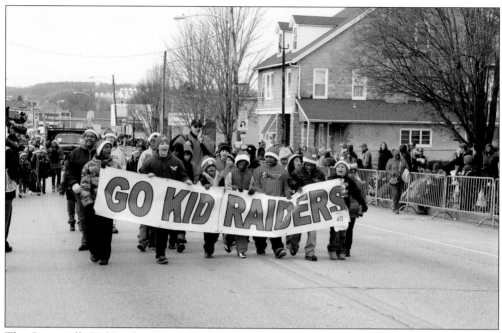

The Coatesville Kid Raiders march in the 2013 Coatesville Christmas Parade. The Kid Raiders are a nonprofit volunteer youth football and cheer organization for children within the Coatesville Area School District and surrounding areas. (Author's collection.)

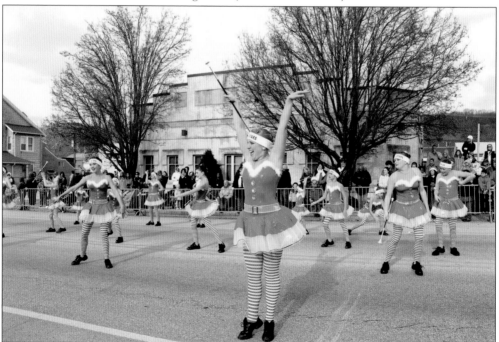

Members of Russell's Dance and Baton Studio from Wagontown, Pennsylvania, perform in the 2013 Coatesville Christmas Parade. Over the past 20 years, Russell's All Stars have produced over 60 individual champions and over 200 state and regional champions. Under the direction of Elaine Russellver, 100 teams have become national champions. (Author's collection.)

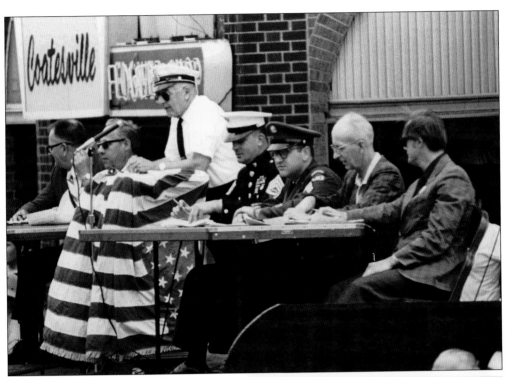

These folks in front of the original
Coatesville Flower Shop at 334 East
Lincoln Highway are providing
commentary during a fireman's parade.
(Courtesy of the Coatesville Flower
Shop and the DePedro family.)

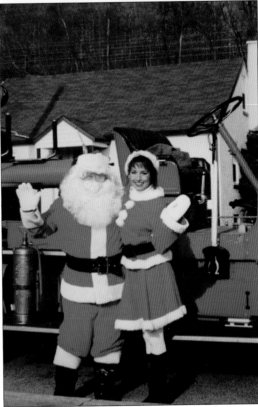

Santa and Mrs. Clause (the author,
Karol Collins) get ready to appear
in the 1997 Coatesville Christmas
Parade. (Author's collection.)

A mummers string band marches in the 1963 Coatesville Christmas Parade in the 700 block of East Lincoln Highway. (Courtesy of Robert Collins.)

The 1963 Coatesville Christmas Parade marches along East Lincoln Highway past Sante's Drug Store (now the Royal Bouquet). (Courtesy of Robert Collins.)

What began in 1973 as a one-day event on the grounds of the Coatesville City Hall has grown into a four-day extravaganza on the ground of Brandywine Hospital, attracting over 25,000 guests—the Brandywine Strawberry Festival. Originally organized by the nurses at the Coatesville Hospital to raise funds for a nursing scholarship, the festival grew to be one of Brandywine Hospital's most successful fundraising events. More than 10 years ago, the Brandywine Health Foundation took over the strawberry festival, and since then the event has grown in size and stature and become a significant source for revenue for the foundation, giving back more to the community each and every year. Pound cake, vanilla ice cream, strawberries, and whipped cream make up the famous strawberry shortcake that is served at the Brandywine Health Foundation's annual festival. This photograph was made at the 2012 festival. (Author's collection.)

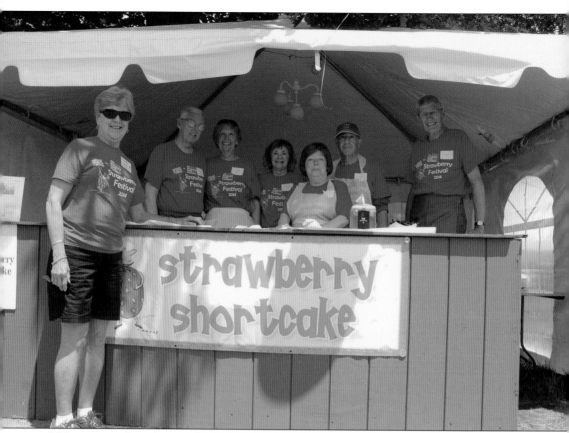

Volunteers work at the strawberry shortcake booth during the Brandywine Health Foundation's annual strawberry festival. Pictured in 2014 are, from left to right, Marlene Recchiuti, RN (committee member since the first festival), Ed and Robin LeDrew, Ruth Ann Fleet, Gail and Frank Cimbola, and George Fleet. (Author's collection.)

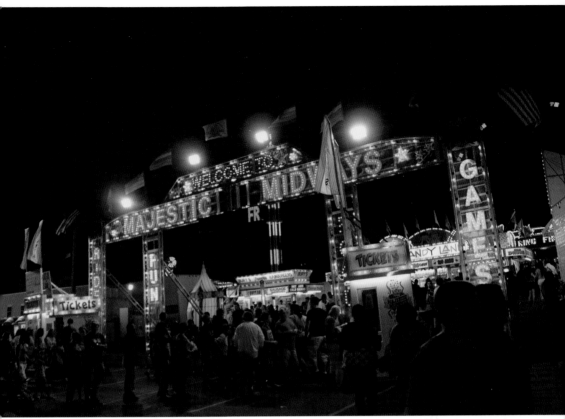

Crowds wait to purchase tickets for an exciting ride at the entrance of Majestic Midways at the Brandywine Health Foundation's annual strawberry festival in 2014. Coatesville Rotary Club volunteers man the ticket booths for the entire four-day festival. (Author's collection.)

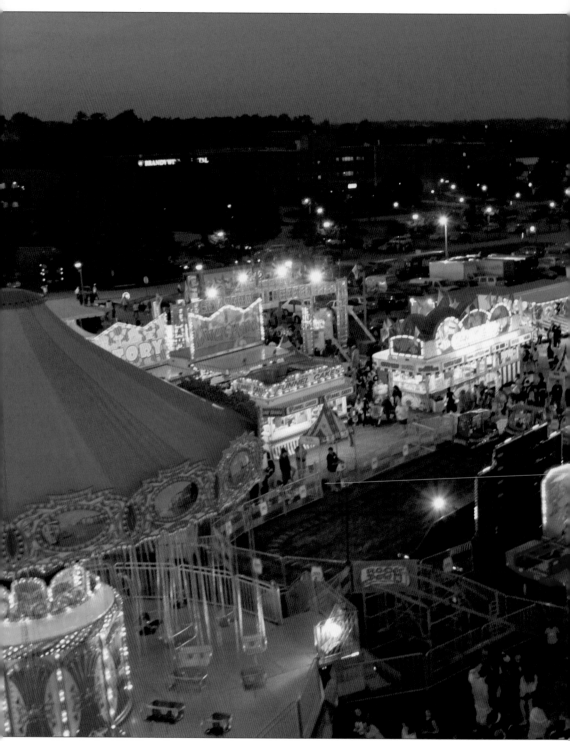

Here is the 2014 Brandywine Strawberry Festival as seen from atop the Ferris wheel. Brandywine Hospital can be seen in the background. Although Brandywine Hospital still hosts the festival and generously donates over $10,000 in in-kind services, since 2001, the festival has benefited a

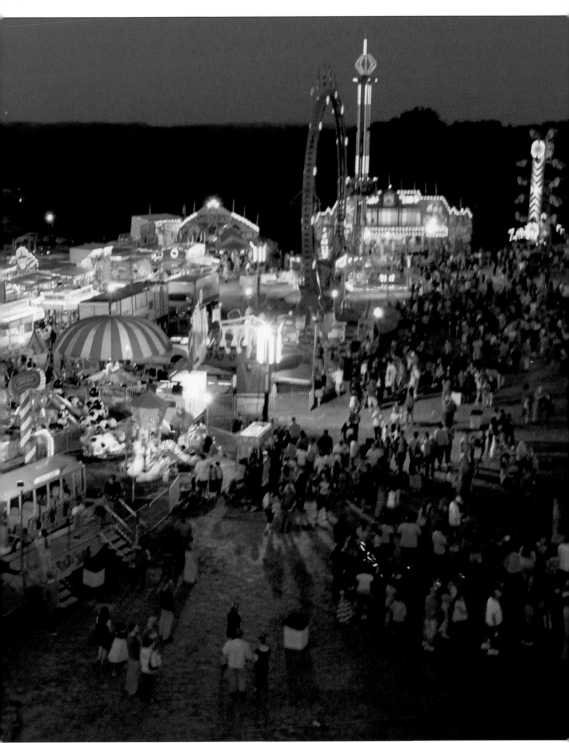

variety of health and human-services organizations in the community and the Coatesville Youth Initiative through the Brandywine Health Foundation as well as the Coatesville Rotary, the Thorndale Volunteer Fire Company, and the Coatesville Public Library. (Author's collection.)

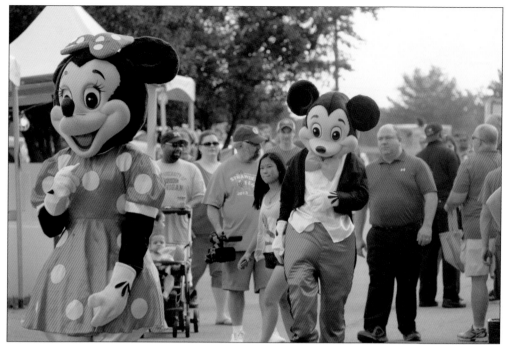

Mickey and Minnie Mouse mingle with the crowd at the 2013 Brandywine Health Foundation Strawberry Festival. (Author's collection.)

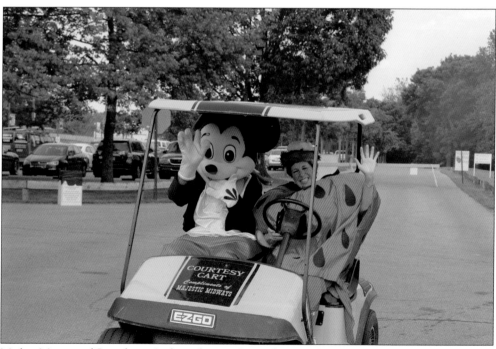

Mickey Mouse and Strawberry Lady are having fun at the Brandywine Health Foundation's annual strawberry festival in 2013 on the grounds of the Brandywine Hospital. (Author's collection.)

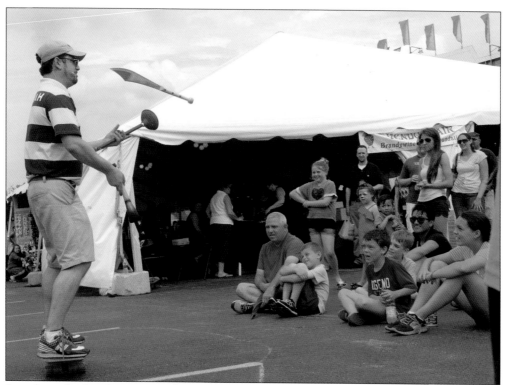

Jonathon the Juggler amazes the crowd by juggling a knife, a torch, and a plunger while balancing on a skateboard at the Brandywine Health Foundation Strawberry Festival in 2013. (Author's collection.)

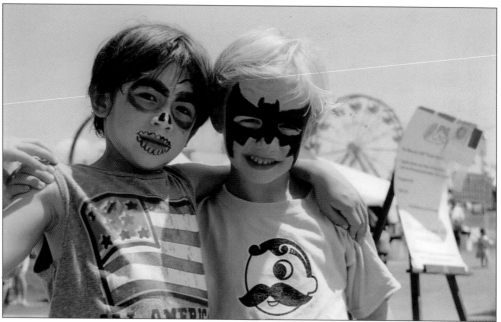

Carson Spangler (Batman) enjoys the 2013 Brandywine Strawberry Festival with his buddy Cole Pham (skeleton). (Author's collection.)

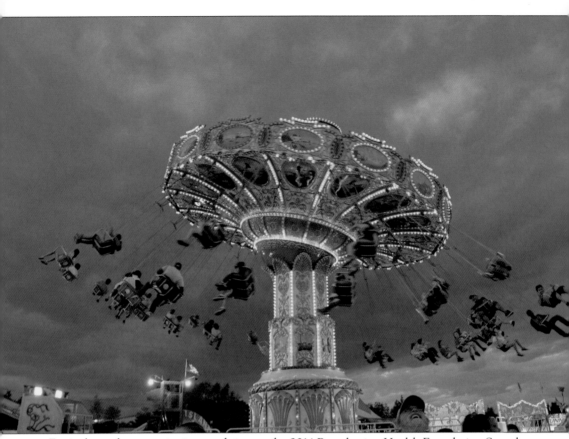

Festivalgoers have a swinging good time at the 2014 Brandywine Health Foundation Strawberry Festival. (Author's collection.)

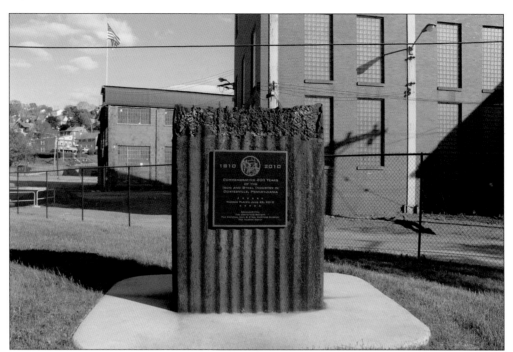

In 2010, a 200th anniversary commemorative marker was dedicated on the grounds of the Lukens Historic District, just behind Terracina. In 1810, Issac Pennock founded the Brandywine Iron Works and Nail Factory, the business that became Lukens Steel Company. The marker is made from a piece of one of the steel "trees" that was once part of the old World Trade Center in New York City. (Both, author's collection.)

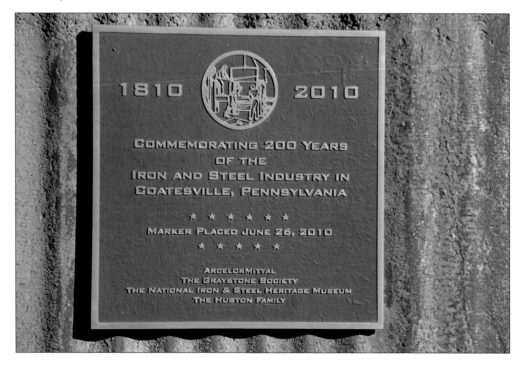

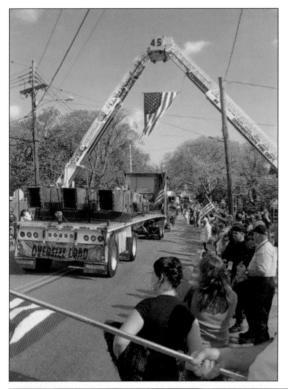

On April 14, 2010, some 500 tons of steel returned to its birthplace in Coatesville, carried by 28 tractor-trailers. The manufacturing of the steel began in 1967 at Lukens Steel and in 1969 the finished product left for New York City via train, becoming what would be the framework for the first nine floors of the old World Trade Center towers. After the tragedies of 9/11, the steel "trees" were still standing, becoming an unforgettable image that would be burned into America's memory forever. Some 41 years later, thanks to Eugene DiOrio and Scott Huston, a 28-truck convoy arrived in Coatesville, led into the city by a distinguished procession. (Both, author's collection.)

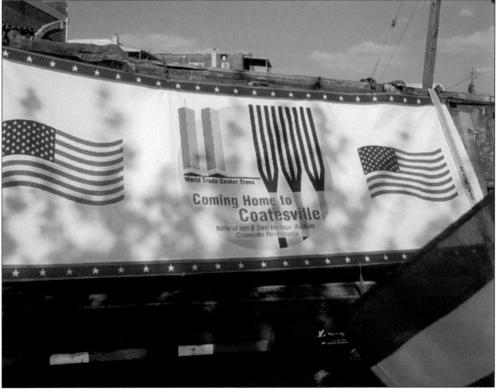

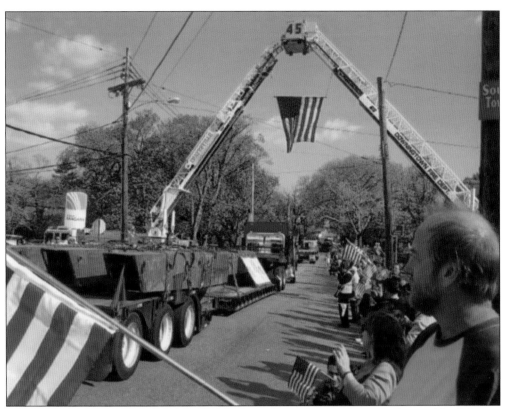

Hundreds of people lined the streets, holding American flags, welcoming the steel back home. (Both, author's collection.)

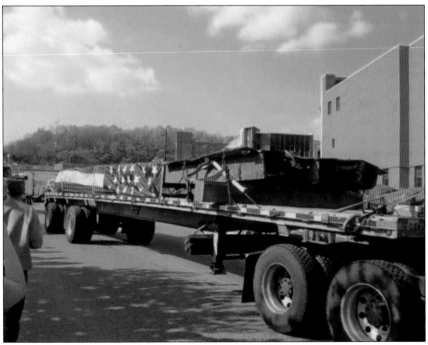

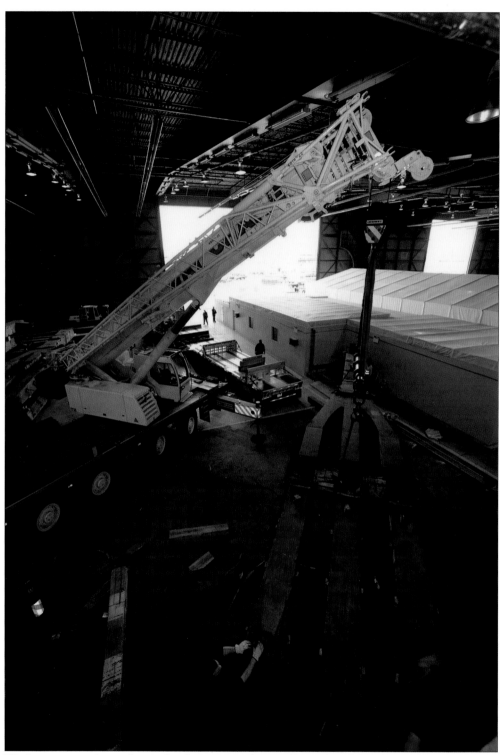

Workers prepare the steel trees for their journey home. (Courtesy of the National Iron and Steel Heritage Museum.)

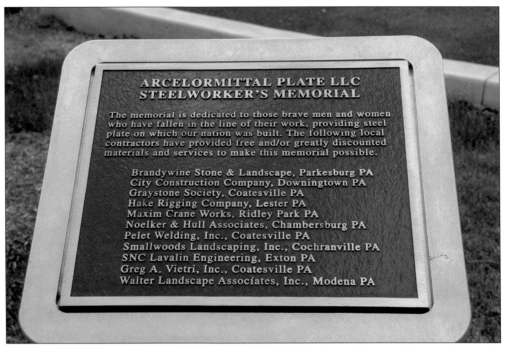

A plaque at the Steelworker's Memorial recognizes those who donated time and materials to make the construction of this important project a reality. (Author's collection.)

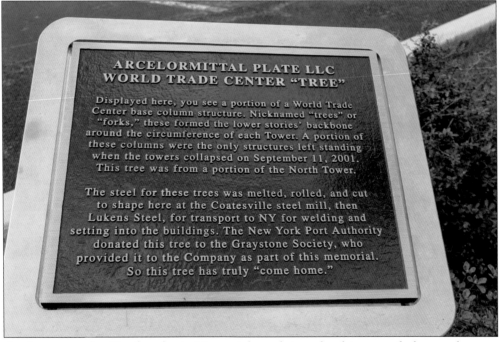

A plaque at the Steelworker's Memorial explains the history of the steel trees. (Author's collection.)

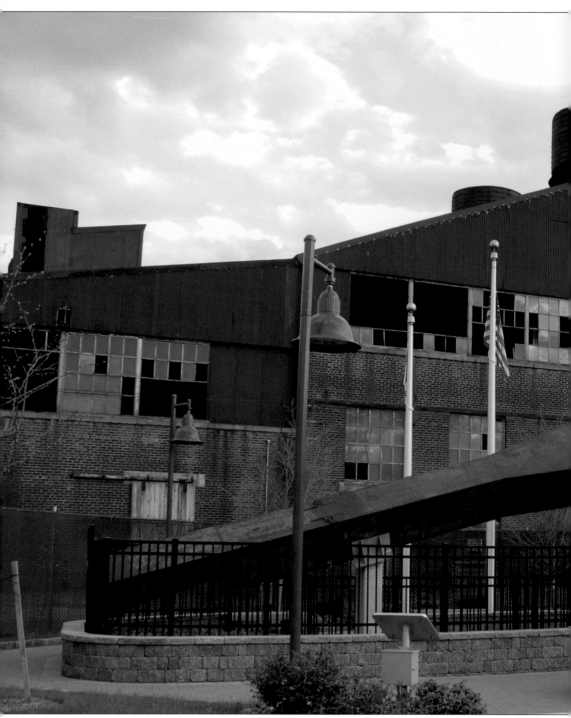

The Steelworkers' Memorial was constructed by ArcelorMittal in 2013. The memorial commemorates those who have perished in the steel mill, as well as those who gave their lives in the line of duty on September 11, 2001. The centerpiece of the memorial is one of the steel trees that was

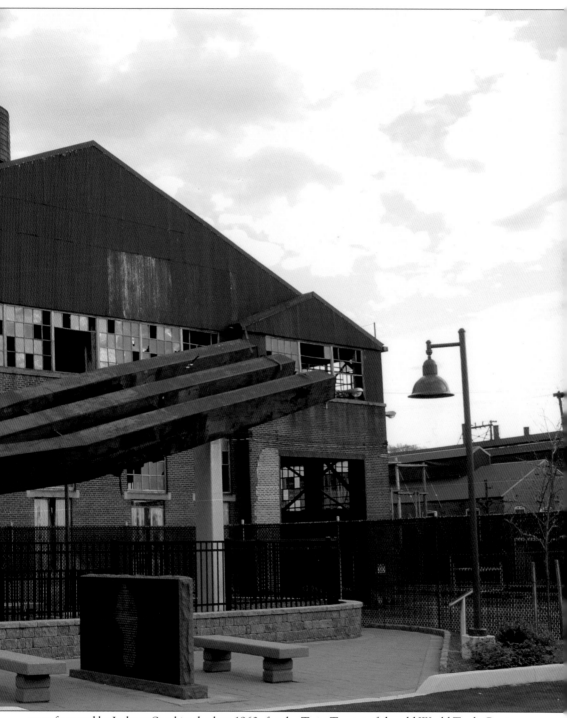

manufactured by Lukens Steel in the late 1960s for the Twin Towers of the old World Trade Center and was returned home to Coatesville in April 2010. (Author's collection.)

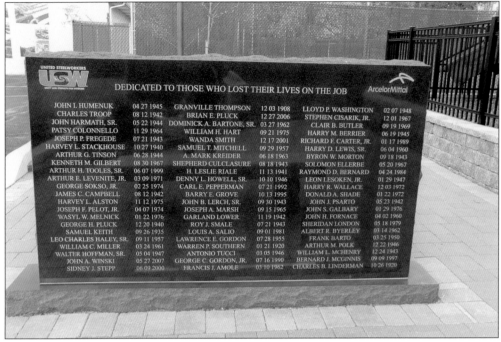

Part of the Steelworkers' Memorial, this marker displays the names of those who lost their lives working in the steel mill. (Author's collection.)

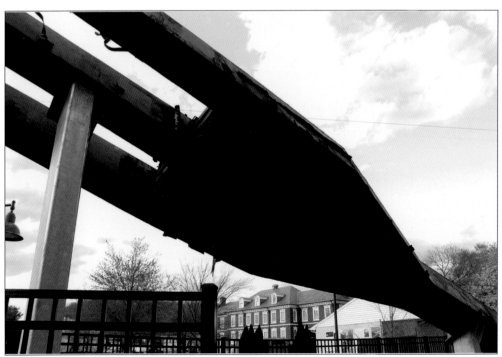

Pictured here is the underside of the steel tree that makes up part of the Steelworkers' Memorial. The Lukens Executive Building can be seen in the background. (Author's collection.)

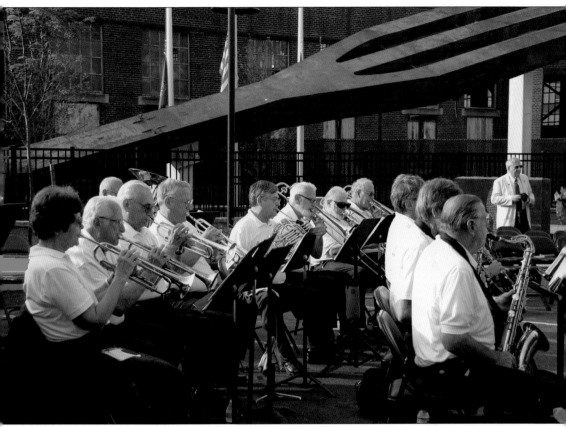

Each year on September 11, the National Iron and Steel Heritage Museum hosts Coatesville Remembers 9/11. The solemn event follows the time line of the actual events that unfolded on September 11, 2001. The program includes musical tributes by the Lukens Band and the Belletones and Redmen, an elite group, as well as the elite choral group Meistersinger from Coatesville Area High School. State and local politicians address the crowd, along with county commissioners, city officials, and Scott G. Huston, president of the National Iron and Steel Heritage Museum. The 2013 event is pictured here. (Author's collection.)

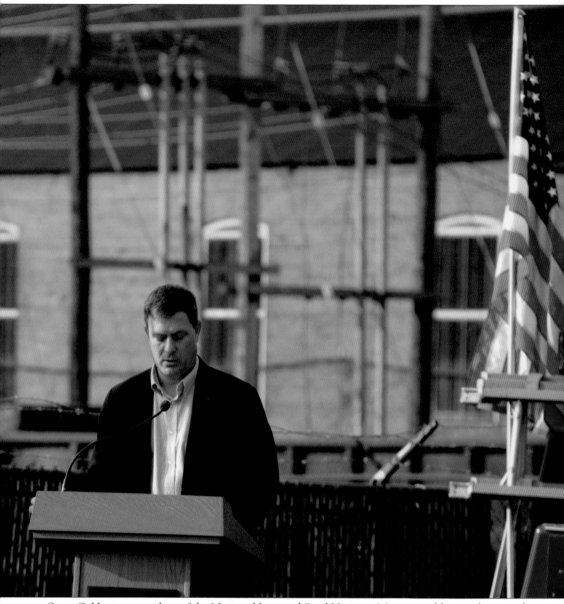

Scott G. Huston, president of the National Iron and Steel Heritage Museum, addresses the attendees at a Coatesville Remembers event on September 11, 2013. (Author's collection.)

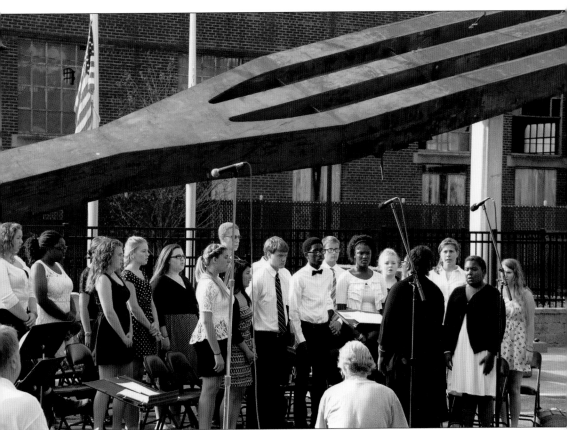

Members of the Coatesville Area High School's chorus group, the Belletones, and Redmen perform under the Steelworkers' Memorial at the 2013 Coatesville Remembers. The event is held each year on September 11. (Author's collection.)

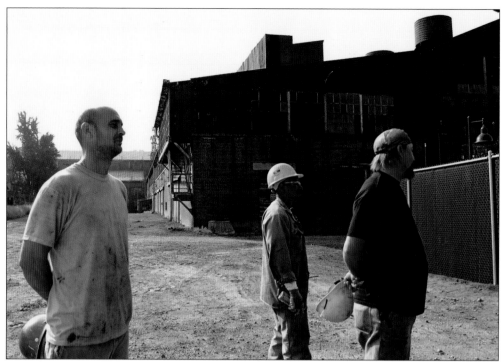

Employees of ArcelorMittal (formerly Lukens Steel) look on during the Coatesville Remembers event on September 11, 2013. (Author's collection.)

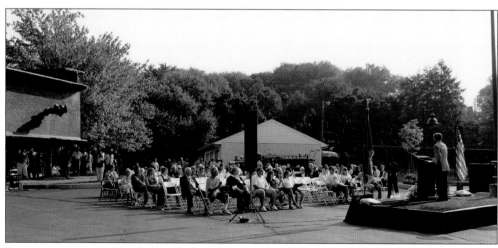

Former congressman Joseph Sestak gives the keynote address at the 2013 Coatesville Remembers event. (Author's collection.)

Six

LOOKING AHEAD

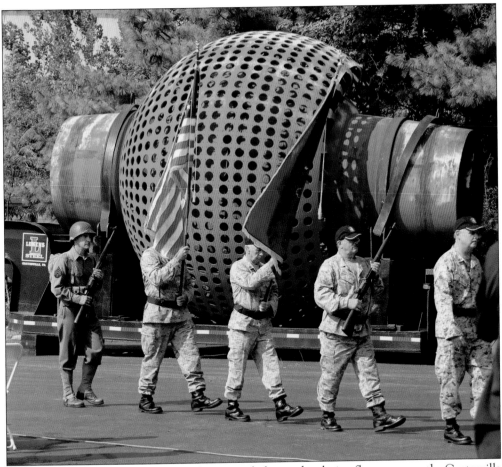

Veterans from VFW Post 4480, Parkesburg, march during the closing flag ceremony the Coatesville Remembers event on September 11, 2013. (Author's collection.)

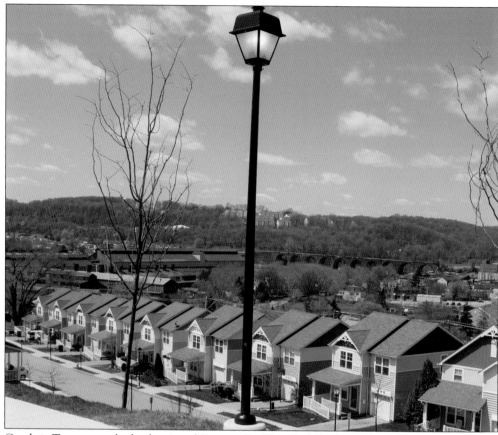

Cambria Terrace overlooks the city of Coatesville. The High Bridge and ArcelorMittal (formerly Lukens Steel) can be seen in the distance. The vantage point gives residents a spectacular view of the city. (Author's collection.)

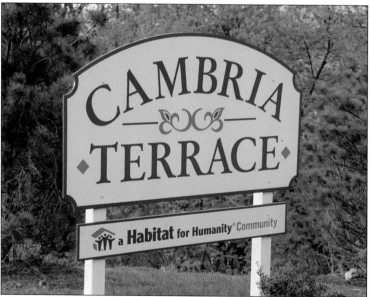

Cambria Terrace, built by Habitat for Humanity, has made the American Dream possible for many first-time home buyers in Coatesville. (Author's collection.)

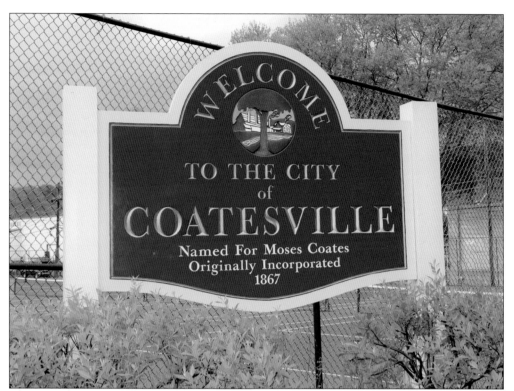

This sign along US Route 30 welcomes visitors to Coatesville. (Author's collection.)

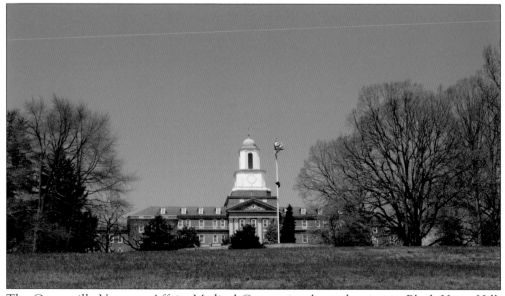

The Coatesville Veterans Affairs Medical Center sits above the city on Black Horse Hill. (Author's collection.)

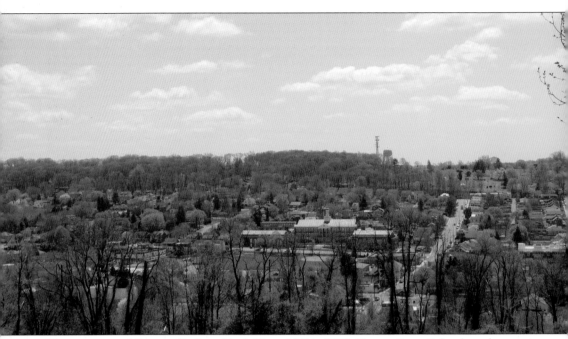

Here is a view of Coatesville from Black Horse Hill in 2015. Horace Scott School can be seen in the center of the photograph, and the Brandywine Center is in the lower right. Fairview Cemetery is in the upper right. (Author's collection.)

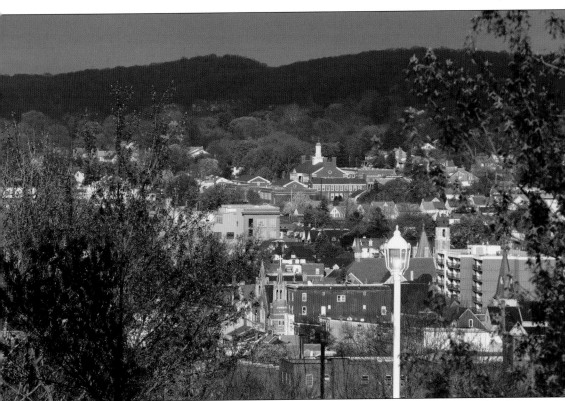

This is a view of Coatesville from the Millview Apartment Homes complex. Scott School is pictured in the center, and the cross from the Lutheran Church of the Good Shepherd on Seventeenth Avenue can be seen directly above. Olivet Methodist Church is in the foreground. (Author's collection.)

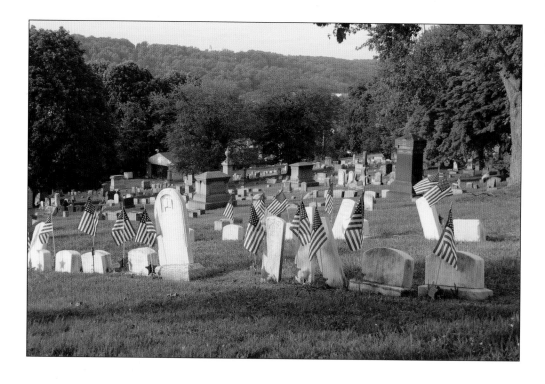

Fairview Cemetery, located at 786 Oak Street, is pictured here on Memorial Day 2015. (Both, author's collection.)

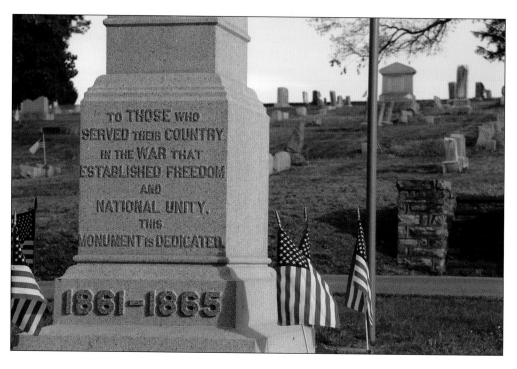

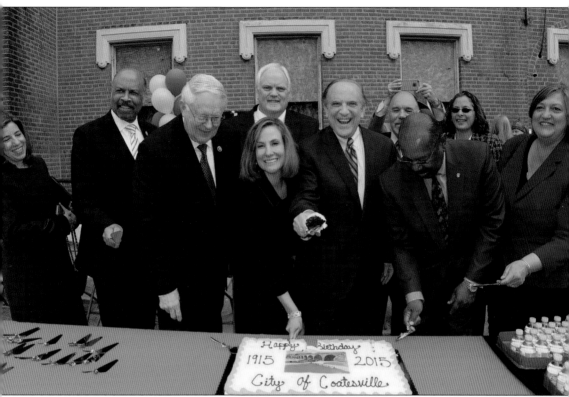

April 27, 2015, marked Coatesville's 100th anniversary as a city. A yearlong celebration was kicked off at the Coatesville Train Station to commemorate this important milestone. Pictured here are, from left to right, acting PennDOT secretary Leslie Richards, Chester County commissioner Terence Farrell, US representative Joe Pitts, Pennsylvania state representative Tim Hennessey, Chester County commissioner Michelle Kichline, Pennsylvania state senator Andy Dinniman, Pennsylvania state representative Harry Lewis Jr., and Chester County commissioner Kathi Cozzone. (Courtesy of Robert O. Williams and the Williams Group.)

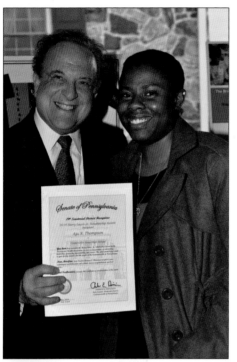

Aja Thompson, a member of the Coatesville Youth Initiative, was the 2014 Harry Lewis Jr. scholarship award recipient. She is pictured here with Pennsylvania state senator Andy Dinniman at a garden party hosted by the Brandywine Health Foundation. (Courtesy of the Brandywine Health Foundation).

After Thompson went on to college, she realized how much her home meant to her and wrote a poem titled "I Love and Miss You." She recently read her poem at the Uniting for Coatesville's Kids event on March 6, 2015, and received a standing ovation. (Author's collection.)

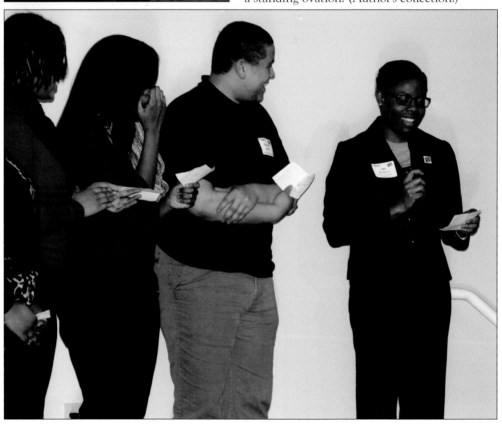

"I Love and Miss You"
by Aja Thompson

I Love and Miss you, Coatesville
My home, the only place I've known
The home that has seen me grow, into this young woman I still have yet to know
I miss your smile, your warm embrace on Saturday afternoons
The delight of your world in June
Your smells like sweet perfume
I miss the sound of laughter that springs from neighborhood cookouts
The music that played from the streetcars at night so loudly
I am proud of me, because of you Coatesville
My faith and strength grew from long strides on your sidewalks
My voice became its own being and my reasoning for believing
in you has become stained in your city walls
I love the pride from our Red Raiders and the dedication of its teachers,
and the Sunday school preachers and the way a day went by
I love the community that felt like family and the family that felt like
a lifetime of spirits rekindling a love that has always existed
I miss and love the buildings and the people, the night and daylight and the cars, and the
voices, and the choices that helped me make a difference, I miss the way the stars look at night
I love and miss you Coatesville, my home you will forever be, I miss and love you Coatesville
My treasure, my hope, the foundation that has made me, me.

DISCOVER THOUSANDS OF LOCAL HISTORY BOOKS
FEATURING MILLIONS OF VINTAGE IMAGES

Arcadia Publishing, the leading local history publisher in the United States, is committed to making history accessible and meaningful through publishing books that celebrate and preserve the heritage of America's people and places.

Find more books like this at
www.arcadiapublishing.com

Search for your hometown history, your old stomping grounds, and even your favorite sports team.

Consistent with our mission to preserve history on a local level, this book was printed in South Carolina on American-made paper and manufactured entirely in the United States. Products carrying the accredited Forest Stewardship Council (FSC) label are printed on 100 percent FSC-certified paper.

MADE IN THE